THE TECHNIQUE
OF
PENCIL
DRAWING

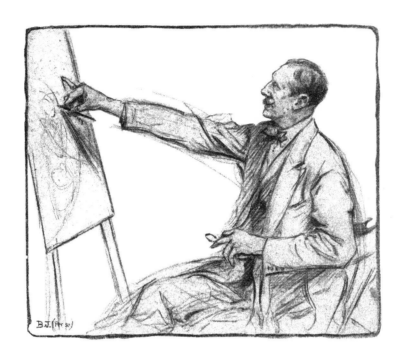

A Self Portrait of the Author.

THE TECHNIQUE OF PENCIL DRAWING

BOROUGH JOHNSON

DOVER PUBLICATIONS, INC.
MINEOLA, NEW YORK

DEDICATED TO THE MEMORY OF

THE LATE COLONEL SIR CHARLES WATSON

R.E., K.C.M.G., C.B., M.A.

AND TO

LADY WATSON OF JERUSALEM

FOR THEIR KINDLY FRIENDSHIP AND GOODWILL

EXTENDED OVER MANY YEARS OF

HAPPY RECOLLECTION

Bibliographical Note

This Dover edition, first published in 2008, is an unabridged republication of *The Technique of Pencil Drawing: With Notes on the Proportions of the Human Figure,* originally published by Sir Isaac Pitman & Sons, Ltd., London, 1930.

International Standard Book Number
ISBN-13: 978-0-486-46925-6
ISBN-10: 0-486-46925-5

Manufactured in the United States of America
Dover Publications, Inc., 31 East 2nd Street, Mineola, N.Y. 11501

FOREWORD

By Frank Brangwyn, R.A.

THAT chalk or pencil is the master of all art is a truth that cannot be contradicted.

The greatest pictures have lived more by their design than by their colour.

This book is written and illustrated by an artist whose fine draughtsmanship, sincere observation and feeling for character, are too well known to need any recommendation from me.

The high quality of his work proves him to be, as many of us have long known, well able to help others by his teaching. To artists and art students, and indeed to all those who appreciate good drawing, this book should prove most useful, and I wish it every success.

A NOTE ON
PENCIL DRAWING

By Selwyn Image

Sometime Slade Professor of Fine Arts, Oxford

PEN and pencil as artistic instruments have this super-eminent virtue in common, namely, the facility with which they accurately and minutely render the contour of forms. For this reason the most famous school of pure draughtsmanship, the Florentine School, and the artists most renowned for pure draughtsmanship—e.g. Mantegna, Raphael, Leonardo, and in later days Ingres—made immense use in their studies of pen and pencil, or of silver-point, which is practically the same thing as pencil.

For young students, certainly, nothing can be so good as a hardish pencil (it is a great deal more easy to use well than a pen is), for these reasons—

(1) That it enables them to render contours accurately ;
(2) That it is easy of correction ;
(3) That it does not lend itself to slap-dash work and showing off ; and
(4) That it is possible to follow the utmost subtleties of curvature with it.

The modern fancy of putting a brush into a young student's hands at once, and setting him to copy natural objects—e.g. flowers—straightaway with it, has a good deal to be said for it, as effects are thus readily produced, and so the student is encouraged. But it should be allowed mainly as a relaxation from the severer and more searching study of pure form with the point of a hard pencil. And this severer study no

vii

A NOTE ON PENCIL DRAWING

artist will ever wholly relinquish, as long as he maintains his seriousness.

Even for light and shade studies, on a smallish scale, young students may profitably be set to make them with pencil. It is likely to induce in them a finer sense of accurate, refined, unexaggerated, true chiaroscuro than either chalk or paint. But of course the studies will be of no great size, for the labour then would be too exhausting, and the effect too slight.

Selwyn Image

INTRODUCTION

L E dessin c'est la probité de l'Art." This true saying, uttered by Jean Dominique Ingres, that sincere realist and impeccable draughtsman of portrait and figure whose delicacy of finish and purity of line in his best work ranks him as one of the most exquisite manipulators of the lead pencil the French nation has produced, leads me to mention the first use in which " lead " was employed by artists as a medium of expression.

About the middle of the sixteenth century lead was discovered in Cumberland, but probably artists did not employ the graphite point for portrait drawing until the seventeenth century, when we find several names of note amongst those using this new medium, plumbago, for portrait drawing. Artists who were prominent at this time for portraiture in miniature drawn with black lead on vellum were Faithorne, Loggan, and Forster ; the last-named artist has perhaps, in his way, never been excelled for fidelity of detail. The portrait of George St. Lo, dated 1701, in the British Museum, shows what the eye is capable of seeing, and if not art of the highest order it is evidence of consummate patience and craftsmanship. The same can be said of those examples by Loggan in the South Kensington Museum. So the highly finished miniature portrait in plumbago or graphite flourished in the seventeenth and eighteenth centuries, not only in England but also in France and Holland, although a form of lead pencil used for writing in 1565 is mentioned by Conrad Gesner, of Zurich.

INTRODUCTION

Silver-point was the medium most closely resembling black lead that was used before the discovery of the Borrowdale Mines in Cumberland, but, being a harder substance, it is incapable of strong black and white effects; neither can it be erased on account of the special quality of the prepared paper on which it must be used.

The subject of when lead was first introduced by artists in Europe is too large for me to dwell on now. The date is uncertain, but I may mention that one of the earliest was Simon van de Pass, 1595–1647. Also an early but indifferent example of lead pencil portraiture by Jacob van Campen can be seen in the British Museum. However, it was not until 1760 that the Pencil Factory of Faber was established in Nuremberg, and later, the end of the eighteenth century, Conté, of Paris, manufactured lead and other pencils as we know them to-day, since when there have been, and are, many other makers of excellent pencils of all sorts.

The customary " point mediums " used by the " Old Masters " of the Renaissance, and before that time, for expressing their preliminary ideas, compositions and life studies, were charcoal, red and black chalk, and the reed pen with bistre.

For the first examples of depicting animal form by the sharpened point or style, we must go back many thousands of years, to the Quaternary period, to find the earliest representations of life and movement by primitive man, who, on the walls and roofs of the caves in which he found shelter, decorated in outline with his sharpened flint, or painted with a few earth colours, the animal life he was accustomed to hunt and see. These incised outlines, drawings, or silhouettes, are often remarkable for their simplicity and correctness of outline, and

INTRODUCTION

serve as a fine object lesson to the modern draughtsman in the selection of the necessary essentials.

In this book I do not claim to teach drawing, much less create an artist. Written words and illustrations, however eloquent they may be, cannot prove to be so efficient and practical an instructor as personal demonstration by an able draughtsman, but it is my hope that I can make the difficult road shorter and easier for the intelligent student if he goes to Nature for his impressions, drawing everything he sees in his own way, in his sketchbook with ever-handy pencil. Then, in time, with industry and a great desire to excel, he cannot fail to acquire knowledge and fluency in drawing.

If we place the standard of excellence on a really high plane, the handling of the lead pencil, more especially in rendering light and shade in portrait and figure, and put down in an intelligent and artistic manner, requires years of constant practice. The technique is difficult. For the method I employ the artist must hold the pencil in the right way, choose his paper and degree of lead judiciously, and draw with precision and rapid observation, with no thought of rubbing out.

The art of drawing with the lead pencil is more neglected than it should be, considering that it is probably the handiest and most expressive black and white medium one can conveniently use, and capable of the widest range in rendering every conceivable tone, from the deepest black to the palest grey, the faintest outline to the strongest, the finest and most delicate to the broadest treatment. It largely depends upon how one holds and cuts the lead. The correct methods can be easily acquired with practice, and with the help, I hope, of the illustrations in this book.

CONTENTS

LIST OF PLATES

LIST OF PLATES

A GALLERY OF MISCELLANEOUS STUDIES

THE TECHNIQUE
OF
PENCIL DRAWING

CHAPTER I

The Correct Method of Holding the Pencil, the way to Cut it, and the Suitability of Papers

FOR the method I employ it is important to select the right degree and make of lead pencil, for there are so many shades, from very hard to soft lead. I myself generally use a first-grade quality BB, with which degree practically all the drawings in lead reproduced in this book have been executed. The first two illustrations demonstrate the wide range of shades, from the palest grey to deep black, according to the pressure used. The chromatic scale of shading as shown was done with only one cutting of a BB pencil, held in the right manner, on suitable paper. I use the word " chromatic," believing that black and white can, in a sense, suggest colour.

The pencil should be held, as shown in Plate III, Fig. 3, between the thumb and the first two fingers ; or, if the pencil is long enough, between the thumb and index finger, but running through the third and little finger, as illustrated in Plate III, Fig. 4. In this way one has great control over the pencil, can keep the edge of the lead point parallel to the paper,

I

and be able to apply pressure of the thumb where necessary in darker tones or decisive touches, all the control coming from the finger tips, in harmony with a flexible wrist. If this method is employed, it is possible, with considerable practice, to render every degree of gradation from the faintest to the deepest shades, with any shape, size or touch, much as a brush can do. The range of effects is infinite ; in fact, this method of pencil drawing or painting is akin to brushwork, as we may see in Frans Hals' portraits, and requires keenness of vision with certainty of touch and tone. The beginner should frequently practise the necessary pressure or touch required to mark the scale of tones and shapes he may need in this most difficult of all ways of modelling with the pencil.

Now the cutting of the pencil is important, very important indeed, in order to obtain the number of touches and tones necessary in such a drawing as that of the man's head shown in Plate XV. One must make the lead point last as long as possible to avoid hindrance in re-cutting, and to do this the lead must be supported by the wood on the side not employed, but cut away to expose the facets of the lead used, as in diagrams A, B, C, in Plate II, so as to obtain narrow or broad touches.

One must have a sharp penknife, and hold the pencil firmly in the left hand towards the top whilst cutting.

There are many kinds of papers, and it is interesting to experiment with different surfaces and qualities, but for general use I find a smooth machine-made demy paper the best, such as chemists use for wrapping up bottles, etc. The only disadvantages this paper has are thinness and liability to change of colour under light. Otherwise it is perfect, and gives beautiful qualities in the blacks. Use the smooth side without the

2

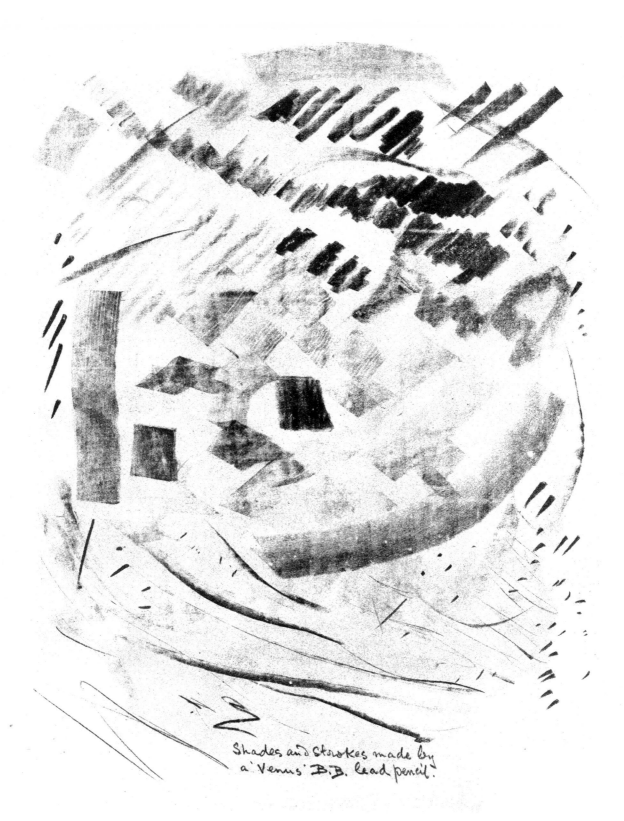

Shades and Strokes made by
a 'Venus' B.B. lead pencil.

PLATE I

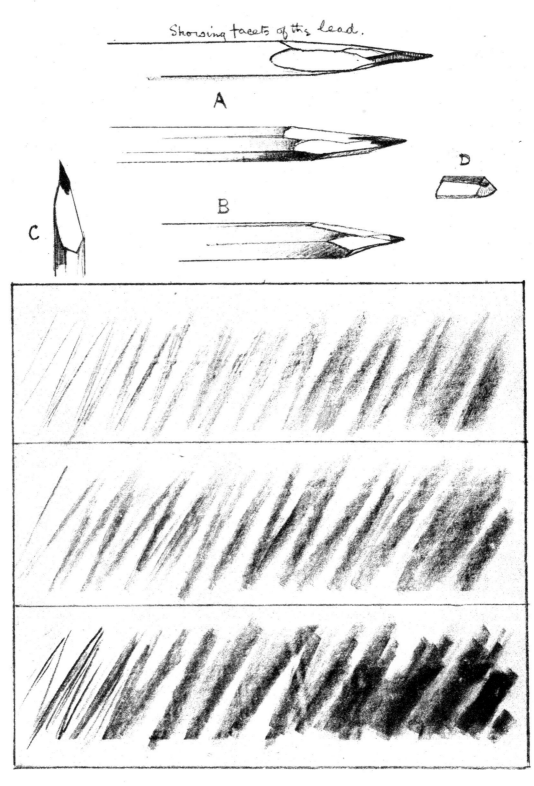

Showing facets of the lead.

A

B

C

D

Shades and Strokes made by a Venus' B.B. lead
pencil cut as diagram C

PLATE II

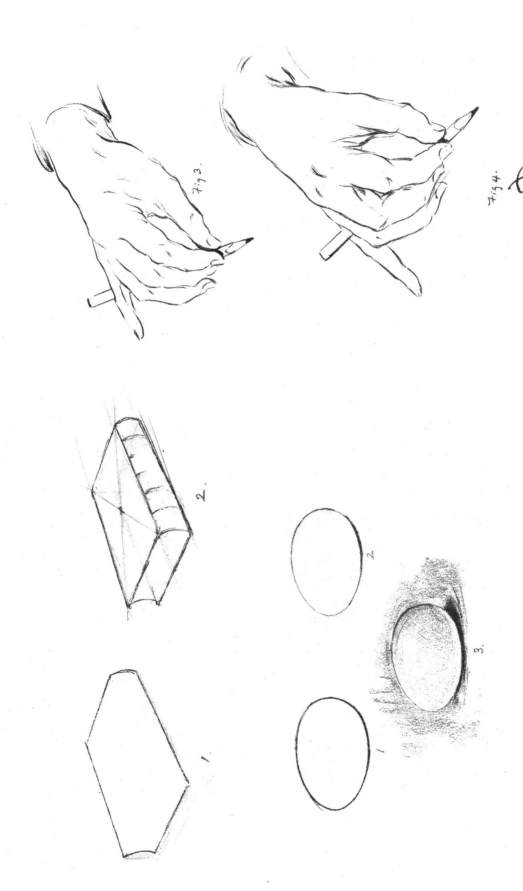

Fig 3.

Fig 4. Diagrams.

2.

2.

3.

1.

1.

PLATE III

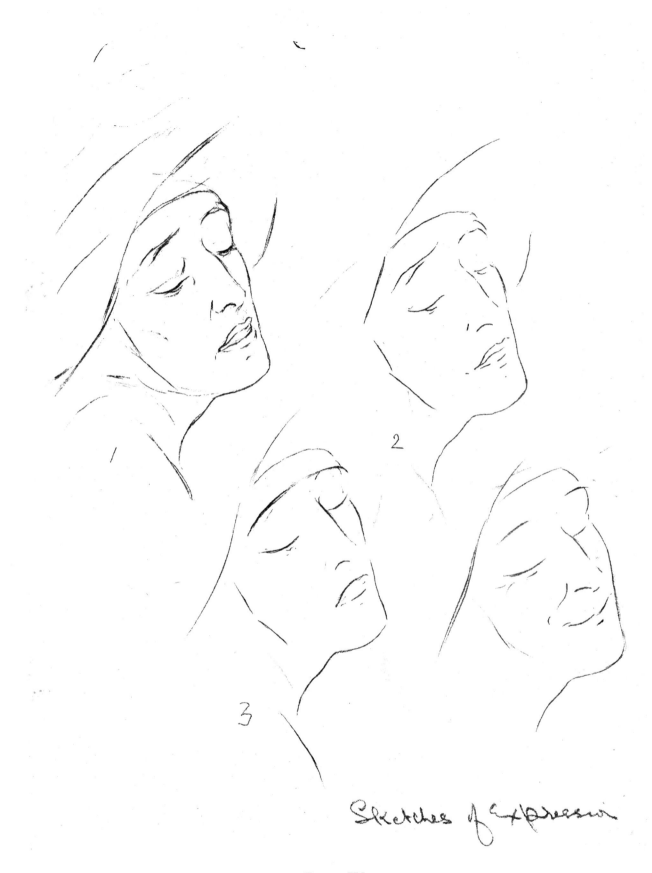

Sketches of Expression

PLATE IV

grain. Then I have used stouter paper, such as cartridge, and any hot-pressed paper. Bristol board is also suitable.

If the paper is thin, it is advisable to work over several sheets placed under the drawing in order to give elasticity to the touch, which materially aids one in securing delicacy and subtlety of modelling and good quality in the blacks.

As to rubber, the less used the better. From the commencement endeavour to avoid rubbing out. Employ it for drawing; for this it is often invaluable. The rubber of a putty consistency is the best; it easily lifts the lead, and is easily moulded with the fingers to a point which can be used for cutting out shapes and high lights.

CHAPTER II

The Commencement of a Drawing and the Value of a Rapid and Essential Outline

WHEN I speak of outline I mean all that depicts form without tone, that is to say, even a few dots and short strokes suggesting features with their main expressions as we see so wonderfully done in the sketches of Rembrandt, and of Forain, who with a few deft touches tells his story so vividly. So outline comprises the smaller inner forms and features as well as the larger contours. To show my meaning more clearly I have drawn the principal lines of a nun's face, showing the expression characteristic of grief, the first three outlines retaining the emotion, the fourth reduced to the merest essentials.

If we study the muscles of the face with their mechanism relative to the conditions controlling the emotions, we find they all conform to precise rules and reasonings and show that each passion has a distinct line of direction. For instance, the opposite of sorrow is laughter, in which the lines of the mouth and nostrils rise upwards with the eyes horizontal, so it is quite possible to represent each mood with a few simple strokes, provided we give them the right characteristic direction (Plate IV). To do this we must understand the anatomy of expression, which all portraitists who make a study of physiognomy do. Expression does not lie solely in the features but in the attitude of the body and its separate parts, particularly in the hands, which are more often than not neglected.

4

COMMENCEMENT OF A DRAWING

Anyone with ordinary intelligence and application can learn to sketch more or less " correctly," provided he has a capable master continually at his elbow to point out his mistakes ; for to see proportions, facts and forms scientifically needs much practice and experience. To observe with an artist's eye is another matter altogether, and is a gift which only the aesthetic soul can possess.

My aim in this book is to combine the two essentials ; and I hope to show in this chapter the importance to the inexperienced of the first few lines in starting a drawing. Be the subject an object, landscape, architecture, face or figure, our first general impression is its shape, masses, and principal lines of design, and not its detail, but its form, to be rendered by an outline, which of course has no existence in fact, but is the easiest means of expressing our ideas. To put down that non-existent line in as simple a manner as possible is our first consideration, be the draughtsman a beginner or an artist of experience.

The child with his hazy notion of form, and the savage with his wider knowledge of life and Nature, record their impressions with a sharp point in outline, thus expressing in the simplest manner the things they have seen or their fancy imagined. Drawing is practically all memory, from the momentary to the longer retained image.

The cultivation of the memory is much neglected in art teaching, where only too often art education is repressive of personal initiative and individuality, art deadening instead of being vital and inspiring. What we need is more the teaching of Lecoq de Boisbaudran, where memory played such a great part, and whose school in Paris in the middle of the last century

was productive of such excellent results. We have only to study the prints and drawings by Japanese artists of the eighteenth and nineteenth centuries to see what cultivation of the memory can effect. Look at the drawings of the late Joseph Crawhall, who was a genius in this respect, and François Millet, who seldom worked directly from Nature, except in his student days, for the reason, as he said, that " Nature does not pose."

The art of drawing from life and Nature is not a convention of imitating all one sees, but should be a simple and searching statement of essential facts and solid forms, for the whole is greater than its parts.

The contour of a nude figure, the outline of any object, if drawn with artistic understanding, can convey an impression of three dimensions, or solidity, as well as a shaded drawing. By this I mean not a continuous, unvarying line, with no suggestion of light and shade, and lost and sharp edges, but one stating the sense of vision with that of touch. This may sound impossible to the beginner, but as he progresses the truth of this statement will, I hope, be proved.

If we draw an egg against a white ground, in pure outline, as shown in the first diagram in Plate III, with an unbroken line of even strength and thickness, it conveys to the mind nothing more than an oval. But if we draw it like the second diagram it suggests by its varying strength of line, though still kept continuous, light and shade, and therefore something tangible ; and in the third, this is emphasized owing to its contour coming sharp against the shadow, and lost or faint against the lights or equal tones to its background.

This fact, as demonstrated by this simple example, seems to

6

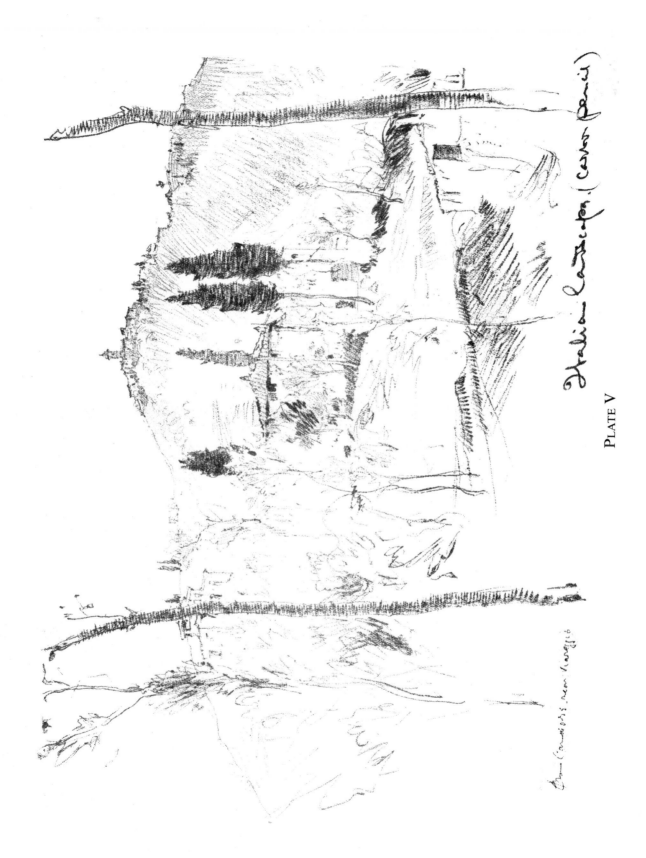

Italian landscape. (Carlo Bonni)

PLATE V

Ergo. (Outline in Curves)

PLATE VI

PLATE VII

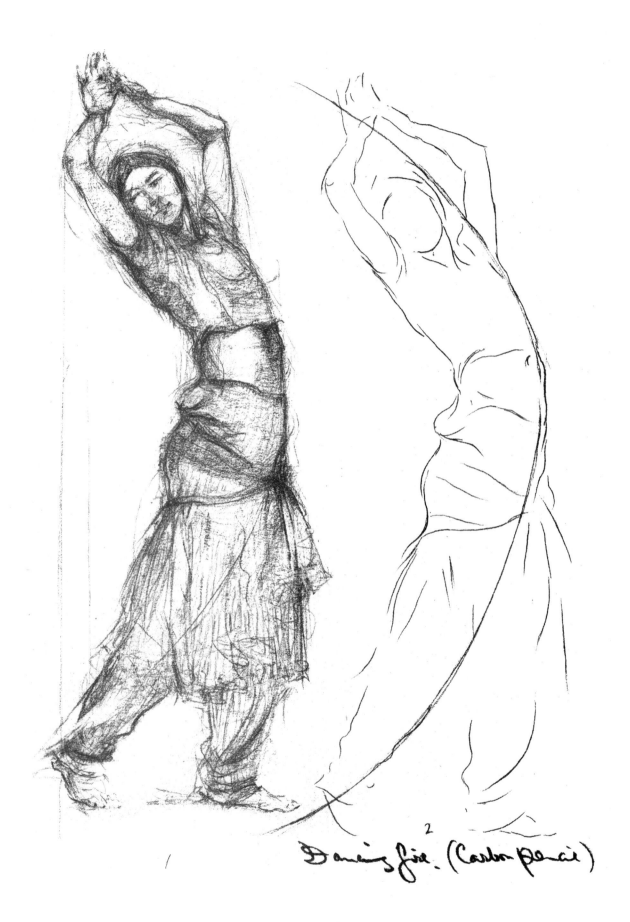

Dancing fire. (Carbon pencil)

PLATE VIII

me to be the whole essence of suggesting modelling or solidity by outline, and should be applied to everything one draws from life or Nature.

Again, if we take a rectangular object, such as a book, and try to represent its three dimensions by a line all round its outer edges, it suggests nothing in particular, and is obviously the most difficult way of proceeding; but, if we see it as I have sketched it, commencing with the longest top line and adding the three additional lines, it is an easier matter, and represents the object. So we could go on *ad infinitum*, but these two examples are, I think, all that are necessary to explain my meaning to the beginner.

When we sketch in a landscape, assuming that we are acquainted with the rules of elementary perspective, our first few lines, seen in our minds, should give the prevailing decorative curves and darkest accents running through the subject.

The two drawings on Plates VI and VII will, I think, explain my meaning clearly.

A slight sketch, as the " Italian Landscape " (Plate V), gives the idea, by its varying strength of touch, of aerial perspective, and light and shade. This a hard, even line could not do. At its best it would be but mechanical, although it may be correctly and beautifully drawn.

Before sketching in the outline of a figure, nude or clothed, more especially if he wishes to represent movement, the beginner places on his paper a few leading lines to give the principal curves or swing of the figure, as I show in Plate VIII. These are the principal lines upon which we build— the scaffolding, so to speak. The able figure draughtsman

does not necessarily place these preliminary lines upon his paper, but he always sees them in his mind.

The same applies if we draw a head, as in the drawings that conclude this chapter. It will be seen that its shape is reduced to curves, which illustrate the principal leading lines encircling the head and give its shape and tilt. The rectangular lines are indicated to show the placing of the ear, sometimes nearly at a right angle to the facial. It would be necessary to extend this principle of angles were I writing a treatise on the teaching of drawing more than on the technique of the pencil.

Before starting a drawing, whatever it may be, we must look at our subject with a view to selection ; and, if it is a view or a crowd of figures, we should see that the eye can comfortably take them in, without movement of the head to the left or right, for we do not wish to worry our eyes with a panorama or cinema film. In placing the subject, be it large or small, we must see that the design is pleasing and suitable in its proportions for the space it is to fill ; for design or pattern is essential to the making of a pleasing picture, and can only be felt, not taught.

The study of the outline, edges or extremities of the nude figure, or of any other object, is not concerned with definite lines, but with mechanical, for the termination of a colour—and everything we see is colour—is connected with or gradated into that of another ; therefore, as a definite line cannot be perceived, it should not be pronounced so distinctly in those objects which are distant as in those which are in the foreplane of the picture.

If we study a nude figure, the nature and quality of the background determines the sharpness or softness of the edges of the convex forms and the variation of values between the boundaries of the figure, resulting in sharp or soft edges, the

8

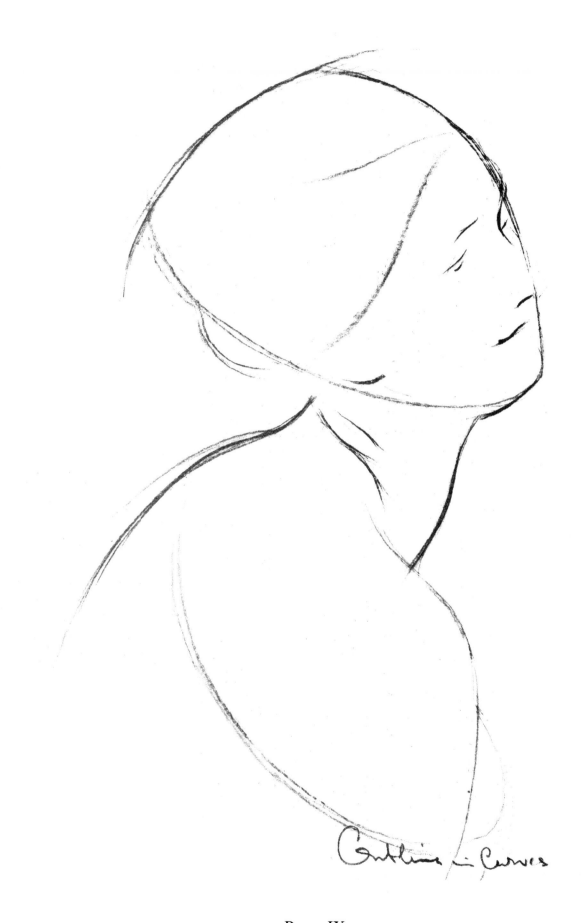

PLATE IX

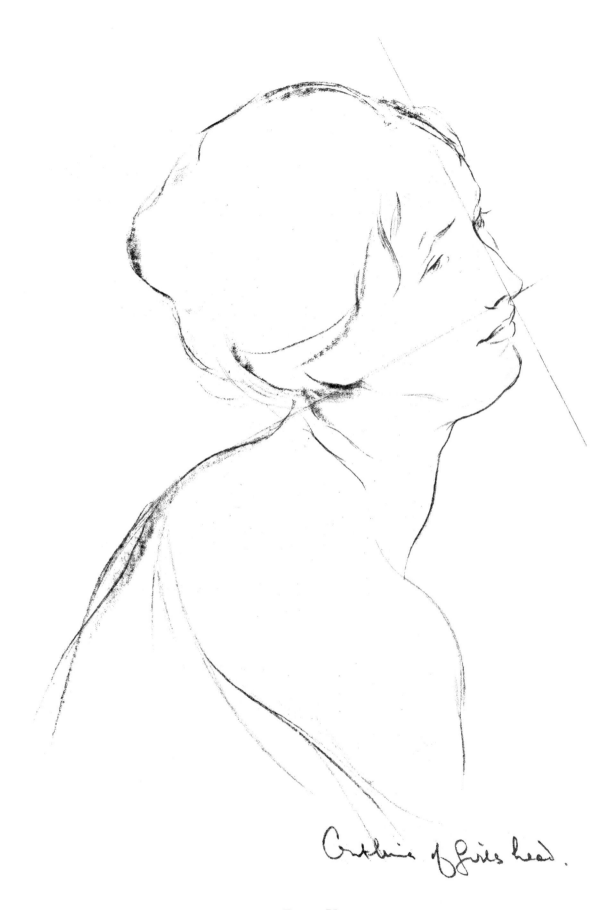

Outline of Girl's head.

PLATE X

mixture of the two adding to the effect of *relievo*. The management of edges denotes the artist's sensitiveness to form, perhaps more than any other faculty of draughtsmanship.

As I am writing primarily upon the way to use a pencil, I will touch only upon the larger subject of composition. We all know there are certain conventional rules of composition as invented by the early masters and imitated and followed slavishly ever since in many academies. The greatest pictures have been invented and naturally composed by those artists who got away from predecessors' rules and hackneyed traditions and followed their own imagination and ideas founded upon truth and suitability. As a modern example, I may mention Brangwyn, from whose designs the student can learn much. Here we see light and shade most effectively disposed, the balance of his masses well considered, and his shadows most happily placed. Those who saw his memorable exhibition at Queen's Gate, in 1925, cannot forget the deep impression left of this great British master's work.

The cinema can teach the black and white artist a great deal. Many of the films we see are strikingly fine as natural compositions of instantaneous movement and outdoor effects of light and shadow. We should never forget that the mental note, with a sketchbook always handy to fix swiftly the fleeting effects of Nature and movement, is the best educator of all. Thus will the hand be made expert by practice.

CHAPTER III

Individuality or Mode of Expression

THE personal character of a man is not necessarily reflected in his work; but in the abstract, as applied to art, individuality, generally termed " style," is a quality of the artist's mind characterized by distinctive features of feeling or emotion and transmitted from his brain to his hand. This sense is not acquired by imitating others who possess it in a larger degree : it must come to us naturally from knowledge gained from experience and a love of Nature. Our work, be it drawing, painting, music, or any fine or applied art, should reflect our temperaments or sensitiveness in a lesser or greater measure, according to the individual and the emotions he receives.

Personality, or the artist's way of drawing what he sees, either in his mind or by his eye, based upon study and structural fitness, is a sense of the highest order. I mean by this the manner in which we put down a line or handle or invent a picture, for as we write so should we draw, in an easy and natural way. If impelled by the longing to represent what his mind conceives, or his eyes see, the accomplished draughtsman cannot fail to impart this power of originality or style to his work. Drawings which lack personality may be correct in every detail, but they are dull and lifeless as a whole, and, being mechanical productions at the best, are worthless as works of art.

10

INDIVIDUALITY

The most vivid impressions of an artist's temperament, if he feels deeply, are shown by his drawings and preliminary studies ; they present to the art student and connoisseur the most interesting part of his work. We often wonder why modern etchings fetch such high prices at sales, whilst original drawings, of which there can be no repetition, often by the same artists, can seldom find purchasers. A fine original drawing, artistically and speculatively, is quite as personal as an etching, and should be valued at a higher rate than any print which can be published by the dozen. This inadequate state of things has a most damaging effect upon original work in black and white, and is one cause of its neglect.

Ingres, whose drawings should be studied closely by all art students, was a stylist in his precise, rather matter-of-fact, way. Little accident can be seen in his drawings, still less in his paintings. Great as he was technically, there is not much human interest ; he makes few mistakes, but often shows consummate good drawing, with perfect eyesight. His opposite, an equally great draughtsman in another way, is the modern master Degas, an impressionist of movement and master of " style," and an artist whom only an artist can perhaps fully appreciate. Art is chance, chance is art, sometimes, when an artist is responsible for the result ; and this is generally found wanting in the drawings by Ingres. We cannot always take the whole output of a master's work as examples to follow. It is hard to reconcile weak and faulty drawing with such a finished craftsman as Ingres, but it may be encouraging to find that even he could at times draw flabby and boneless studies such as we can see in two or three examples in the British Museum. The same lack of inspiration applies to much of Leighton's beautifully

drawn work ; too much classicism with too little vitality is sometimes a bad mixture. We see the opposite of this in Watts's noble and poetic work, with its big, sweeping outline. Menzel—an artist we can compare with no modern illustrator, unless it be Meissonier, with whom he had as keen an eye for rightness, but a deeper analytical insight into human nature than the Frenchman—has left to his nation a marvellous collection of drawings for his *History of Frederick the Great*, which is a revelation to the student. Menzel had a passionate love for truth. Nature was his only master, sincerity his greatest quality—for which one reads he was not easily forgiven.

First and foremost, I think we should study, from a portrait draughtsman's point of view, the chalk drawings by Holbein, at Windsor Castle. Holbein probably has said the last word in economy of line combined with subtile modelling. His style of drawing is original because it is founded entirely upon the rock of truth. There is an interesting old book of chalk drawings in the British Museum Print Room by Jacopo Bellini, 1430, father of Gentile and Giovanni Bellini, the Venetians, remarkably like faint pencil drawings, and also notable for their apparent senility and ignorance of anatomy. Girtin's pencil drawings of Paris, the British Museum collection, are splendid examples of firm handling, and show how architecture can be drawn by an artist of genius. Our eye must be certain, the mind concentrated, with the hand forgotten, as we play the piano, if we wish to develop a style and see things as we feel them and not so much as others do.

How few people know of the existence of Leonardo da Vinci's cartoon of " The Holy Family," which for some regrettable purpose has been for many years deposited in that little-known

home of Academic Art, the Diploma Gallery, where also can be seen Wells's " Volunteers " and other surprising works. The dominant impression of Leonardo's pyramidical design is that of beauty of expression and rhythm of line and form, conceived in a plastic fashion, akin to the power and delicacy of the Elgin Marbles, purely unacademical in its penetrating vision and execution, yet suggesting perfection of form and movement in the larger treatment of the draperies, the outlines rendered with rapid strokes, the modelling with absorbing love. The lingering enchantment of this magic chalk drawing lies vividly in the loveliness of the expression on the faces of the Virgin and her Mother Saint Anne. There is something altogether indefinable and mysterious in this great master's creation of his type of womanly beauty. It haunts one's memory, as all art will, when the super-mind has given of its best and the artist's soul has touched Elysian heights.

CHAPTER IV

Shading

THE methods of shading are numerous. All of them can be right if the result looks alive and spontaneous ; all may be learnt with practice. There should be no tricks or processes of any sort, no eternal negatives, but a clear straightforward proposition. The stippled modelling is perhaps an exception, for then the life is lost in the labour and the result is often purely mechanical and over-modelled, representing what Cowley calls " laborious effects of idleness." It is an academical system warranted to knock every bit of art out of one, and was once largely practised in our principal art schools, as we can see in the early chalk work, when the artists often obtained their shadows by a meticulous system of stippling and not in the modern broad style. The same may apply to the old-fashioned method of " cross-hatching," sometimes managed artistically, but more often not.

We can express by the pencil, the simplest instrument we can employ, form and modelling by flat tones, pure line (open or close), diagonal line shading, or by following the direction of the form, or even by a combination of several methods, such as is seen in the Irishman's head (Plate XI). If we wish, we can also shade with the paper stump, as in some of Adolf Menzel's remarkable pencil drawings. A splendid artist to study.

When we think of the effect of colour in black and white, we know that all colour is produced by light ; the translation

of this into black and white necessitates a truthful rendering of the object we are shading in its effect against its surroundings. For instance, if we take, say, an orange, which has a striking and positive colour, and place it against a dead black background, we see its value, tone, or colour, and especially its edges appear different from what they do against a half-tone ground, or against a white ground; and this scientific fact applies to everything in Nature which we try to transcribe into monochrome. Now black and white, as pigments, of course, do not exist in anything we see which light falls upon, and we can easily prove this by taking any pure black object, such as, for instance, a piece of coal, and placing it upon a piece of white paper. To represent the colour of this truth fully we need not use black at all, but colours only, even positive ones, under certain effects of lighting, the coal scintillating like unto a black diamond. The above kinds of experiment should be made frequently, and practised with the pencil and brush.

Some ways of shading are more difficult than others, especially what I may call the " Mosaic," or separate touch treatment, of which I shall speak more fully and give an illustration. One thing is certain : we must not see too much, nor be painfully elaborate, but confine ourselves as much as possible to three tones, namely, the most obvious, shadow, half tone and light. These are generally sufficient, if the planes and construction are well indicated. It is important that we should depict what we see in the simplest manner possible, paying more attention to the fundamental than to the trivial, eliminating all that is unnecessary, seeing the whole rather than its parts. " The art of leaving out," that is the thing to go for, from start to finish. Nothing can look more vulgar than an over-modelled

15

nude figure, which is far worse than an over-elaborated outline. All is up when the artist shows boredom in his work. When this unhappy crisis comes he had better stop and try again when in a more inspired mood.

Knowledge and memory are everything. The portrait draughtsman should study a skull and know it thoroughly, and judiciously apply his learning to the head he is drawing.

Without a knowledge of form we cannot understand light or shade. There can be no shadow without substance. As light is the source of all effect, casting shadows faint or dark, on to and from, every substance, solid, liquid or ethereal, it follows that unless we carefully balance these two opposite elements in inventing and selecting our effects, our drawings, whatever the subjects may be, will appear flat and uninteresting. Light is so far beyond what white paint or paper can approach that we can only suggest it by contrast of black and its degrees. We can reach the lowest note, but owing to atmosphere intervening there can be no positive black in Nature, but colour, reflecting the general impression of its surroundings.

The above remarks can apply only to the painter, for of course we do not attempt to match exactly individual tones in outdoor sketching in pencil : we can only suggest colour approximately. We can see only an infinitesimal part of the detail before us, so the effect as a whole is all that we can attempt. As in water-colour drawing, the direct touch, without tricks or experiments, is the most inspiring, and certainly the most difficult.

One cannot draw clothes intelligently without some perception of the figure.

The disposition of drapery or clothes should be in accordance

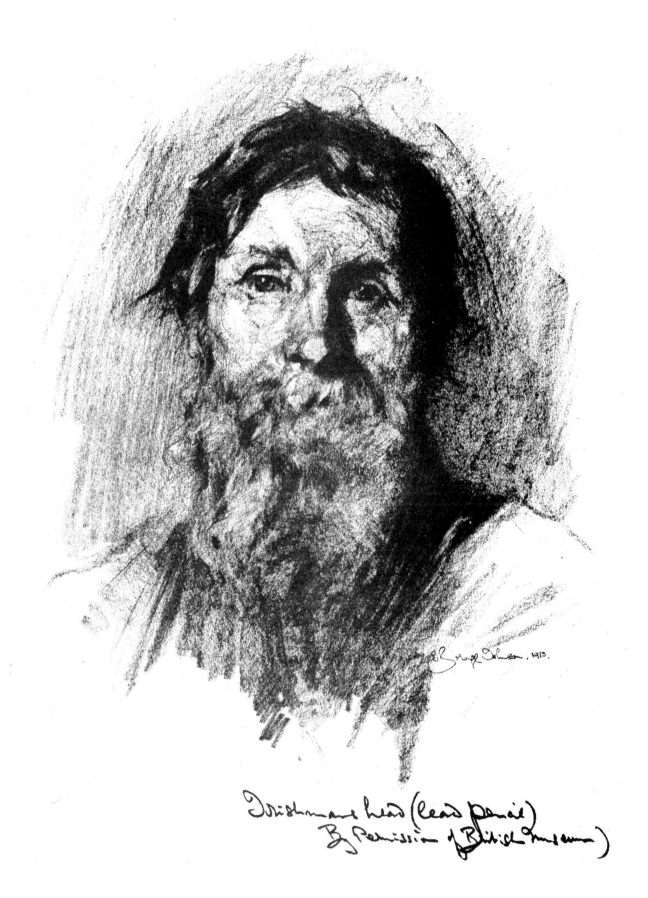

Irishman's head (lead pencil)
By Permission of British Museum)

PLATE XI

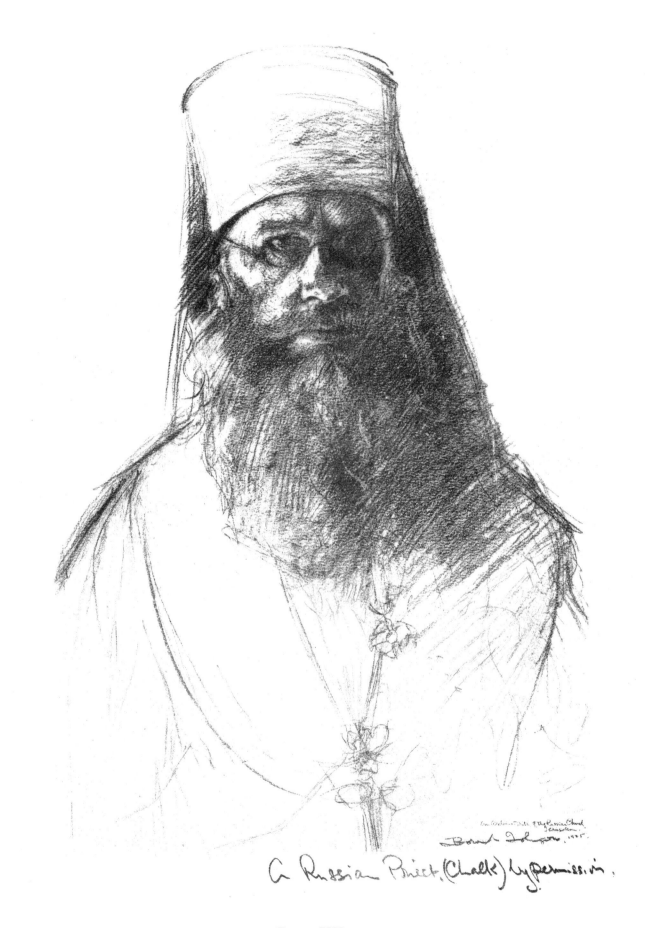

An Ordinand Priest of the Russian Church
Jerusalem. 1905.

Bernard Johnson

A Russian Priest (Chalk) by permission.

PLATE XII

with the body underlying it. How frequently we see in public statues trousers falling in cast iron folds, or statesmen as Roman warriors shivering on pedestals in the British climate. The garments' larger folds should correspond to the movement and turn of the figure. If we draw a moving object, such as a working man carrying a ladder, we must not represent him with a bent wire line all round his clothes, without a stop, or else it will look paralysed ; but break off our contour in places, according to the effect of light and shade, with a double line suggested here and there to convey the idea of motion. We should not draw a whirling wheel spoke by spoke ; we do not see them. Commence all moving forms with a swift, light line, which will probably be wrong. If so, try another until the right position is found, the correct lines being set down more firmly than the others. If the artist looks for detail, or, worse still, tries to draw it, he will be hopelessly lost.

The handling of charcoal and chalk differs somewhat from that of lead pencil in touch and pressure, and requires some- times a different texture of paper. Charcoal is perhaps the most fluent of all dry mediums, and certainly the most suggestive. Then there is the lithographic chalk, perhaps the most fascinat- ing of all and the least understood, a description of which does not enter into this book.

One of the less difficult ways to model with line I show in the head of a Russian priest (opposite), drawn in Jerusalem. Here, it will be seen, the shading takes mainly one diagonal direction, from right to left, a little stumping or rubbing-in with the finger being used in the treatment of the beard.

Far and away the most difficult method of modelling, and yet the most instructive and constructive, is that of which

TECHNIQUE OF PENCIL DRAWING

I give an example in the study of a man's head on Plate XV, somewhat following the system employed by my old friend, the late Lockhart Bogle, to whom I am indebted for much that I know of the potentialities of the lead pencil. Bogle was a draughtsman of the first order, whose technique of the lead pencil in his own personal way I have never seen excelled or even equalled. When drawing a head in tone he used to start with the background, cutting out the head as a white silhouette before shading it : a more difficult method it would be impossible to imagine. I shall try to describe in words my method of working, from start to finish. It will be noticed that practically every tone is a separate shape, put down with the right pressure, and, if possible, not gone over twice, or else the lead becomes shiny and will not mark in the darks ; and if the shading is worried the quality and spontaneity of the handling will be lost. Before attempting this method of shading, one should practise the scale for the necessary pressure of the lead or touch required to mark the different intensities of shades and shapes. As I have drawn this head in order to explain my meaning, it may be less accidental than if I were making the drawing for myself, and, being a tone drawing against a white ground, it is not quite true in effect ; the background, which was a half tone, is left white in order to show the contour of the outlines or edges. The beginner in pencil shading should cultivate restraint and lead up in progressive stages from the simplest method to the most difficult.

For the following head : first visualize the head into constructive angles and planes, then start drawing the contour, top of head to eyebrow, angle and length of eyebrow to commencement of nose, length of nose with its direction in relation

18

to the angle of the forehead, line of side of cheek from brow to chin. Next imagine a line drawn from tip of nose to bottom of ear, judging its distance by eye alone, then angle of jaw and line of jawbone to chin, point of chin, then round the head to lobe of ear, direction of right eyebrow, bottom of nose and mouth, lobe of nose to corner of eye parallel to nose angle. Draw eyes, judging angles from corner of mouth to corner of eye; draw ear, judging angle by comparison with nose, and finish by sketching outline of hair.

In the second stage, first, put in as directly as possible all the darkest shadows seen in the features, hair and jawbone, drawing their shapes as closely as you can define them, commencing with the eyes. Next, the half tones in the same sure manner, leaving the white paper for the lights. Three tones only, all sharp-edged, corrected here and there with the putty rubber. Observe the variety of pressure on contour modelling, and on the bony surfaces, such as the nose, temple, cheek and jaw.

The lamplight study of the old man's head in Plate XVII is treated in the same way, though a little more loosely, and carried farther, the paper stump or tortillon being used for the lighter grey tones.

The old man's head which follows was drawn with a small piece of a soft lead, 6 B, cut as in Plate II, D, and is an example of rapid execution; in fact, one has no time to hesitate in this kind of drawing. It is the most fascinating of all methods, but very difficult of accomplishment; being less deliberate, and the touches left more to chance than in the preceding heads, the result is more alive, if less constructive. One of the important things to remember in this kind of study is to be sure

that your bit of pencil is cut properly, so as to give a broad and even touch, with an appearance of brush work.

The pure line drawing of the Dutch fisherman, in Plate XVI, is noticeable for the free handling of the carbon point, and is a good method to follow. Of course, only practice can give the direction of the line in shading, for it comes naturally, with no pre-conceived ideas, but as we feel it.

In the study of the head of a fisherman, in Plate XIX, it will be seen that the line shading is kept open and free, and carried over a grey tone in the shadows, following the direction of the modelling with a proper regard to the darkest accents.

In the study of the old Dutchman's head (Plate XX), a soft carbon pencil and smooth tinted paper were used. Character and construction are the chief characteristics. The shading was done in various ways, high lights picked out with putty rubber, no stumping employed, three tones only; the skull underlying the flesh well understood, bearing in mind the two main planes, strikingly shown by the light and shadow.

A drawing made with a very fine carbon point is the Italian beggar (Plate XXI). It was drawn in sunlight, line work over a stumped grey tone in the shadows, the whole study highly finished. High finish need not necessarily imply tedious elaboration. More often than not an excess of minor detail wearies the eye, and weakens the effect of the constituent parts, thus detracting from the unity of the drawing as a whole.

The next drawing—a girl's head—is a contrast to the " Mosaic " treatment, and shows a head of a decided type, in which soft and sharp edges, that is, flesh and bone, are rendered by the strength of the touch, and the bony construction suggested by the shape of the lights. It will be seen that the drawing

20

Head. first Stage.

PLATE XIII

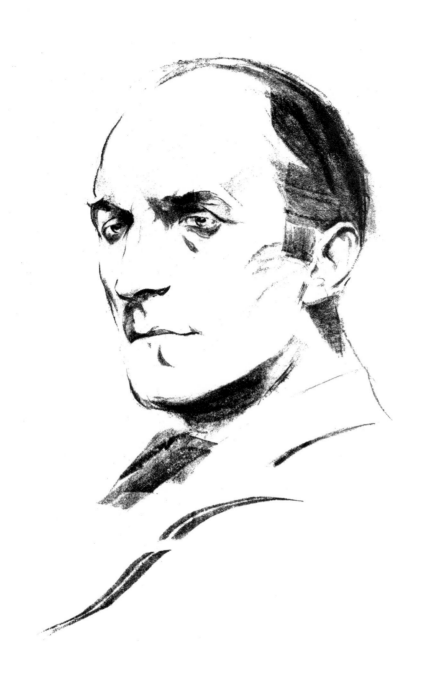

Head. Second Stage.

PLATE XIV

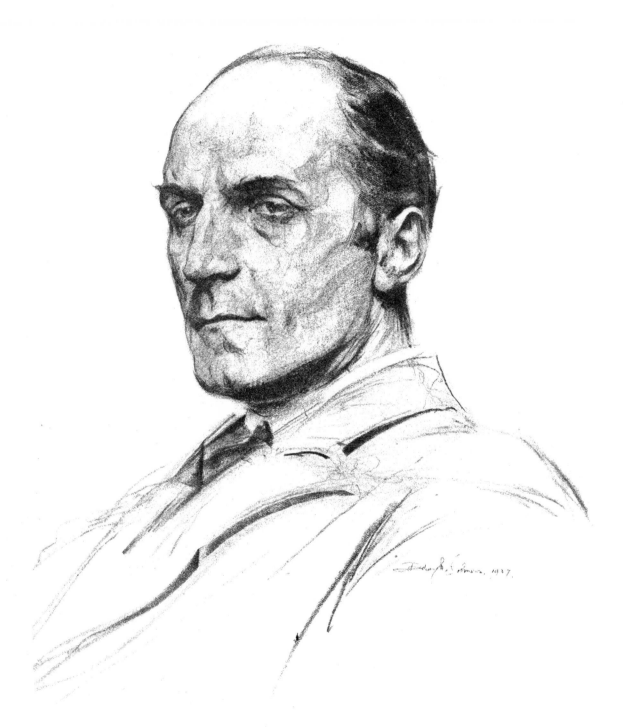

Study of head. third stage. (lead pencil)

PLATE XV

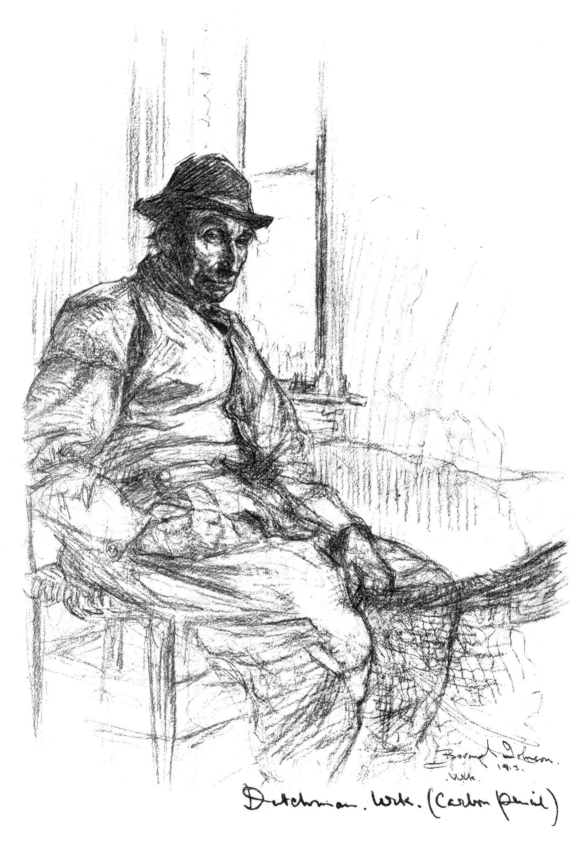

Dutchman. Wrk. (Carbon pencil)

PLATE XVI

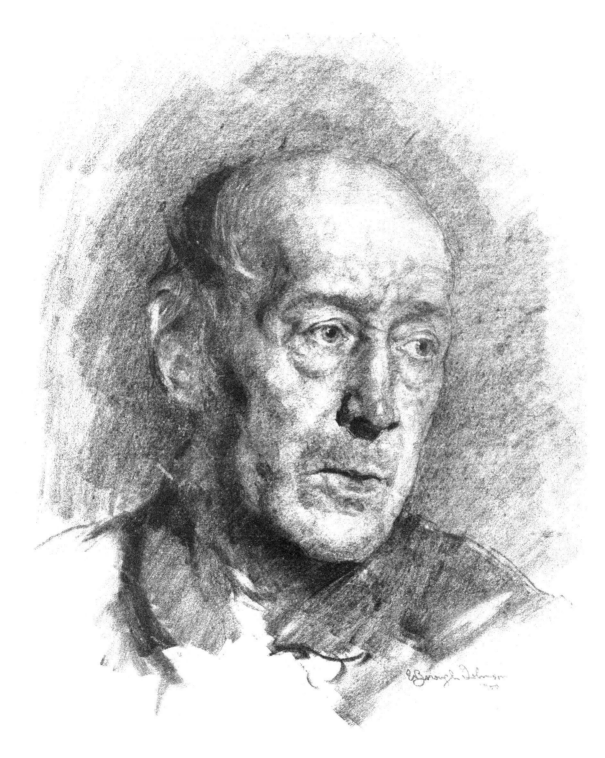

Study of head, lamplight (lead pencil)

PLATE XVII

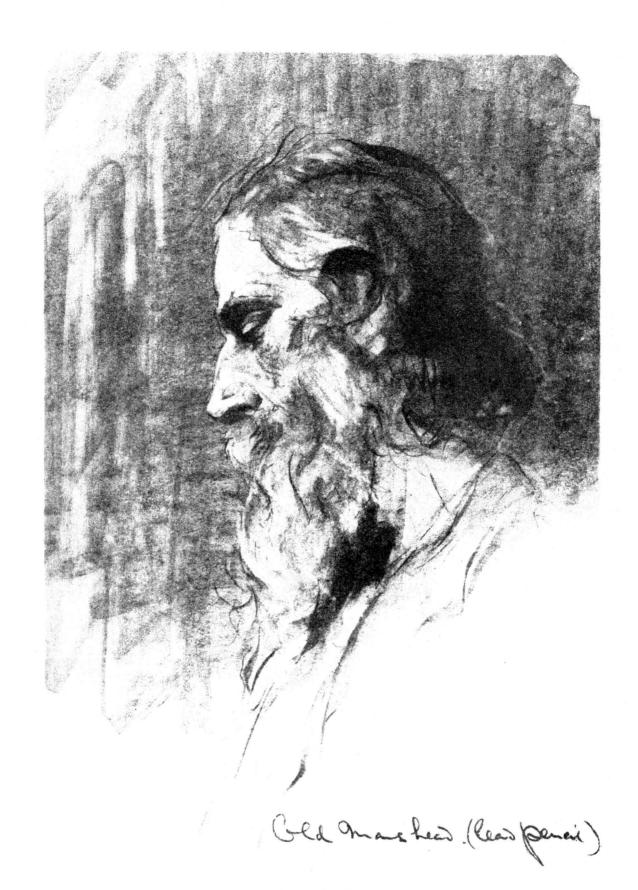

Old man's head. (lead pencil)

PLATE XVIII

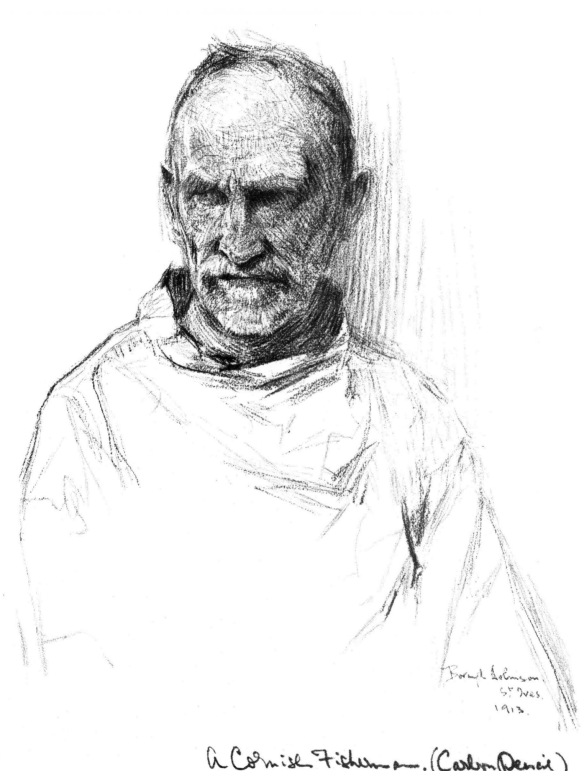

A Cornish Fisherman. (Carbon Pencil)

PLATE XIX

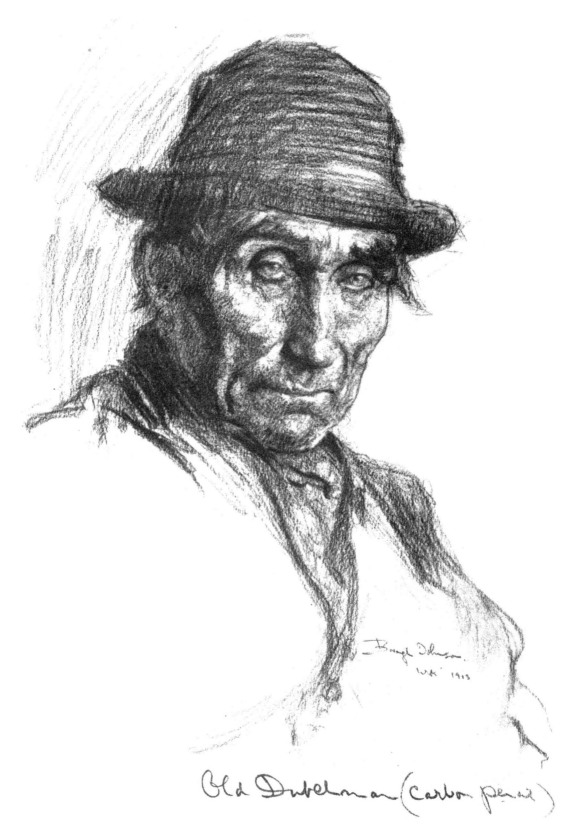

Old Dutchman (carbon pencil)

PLATE XX

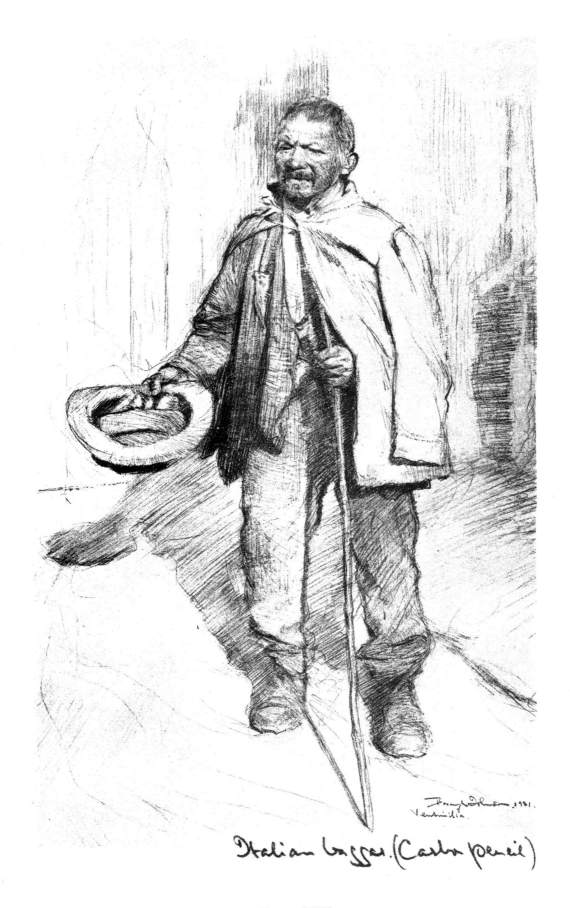

Italian beggar. (Carbon pencil)

PLATE XXI

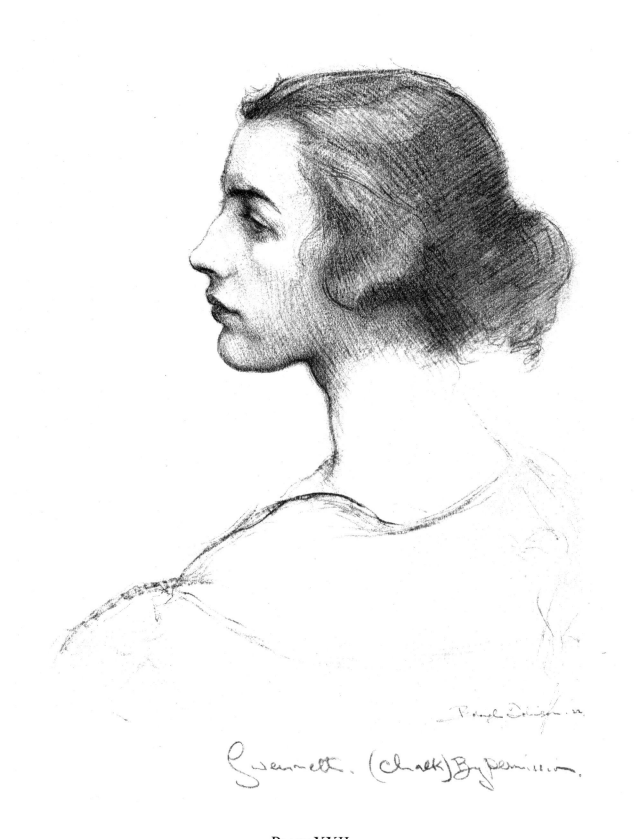

Gwennett. (Chalk) By permission.

PLATE XXII

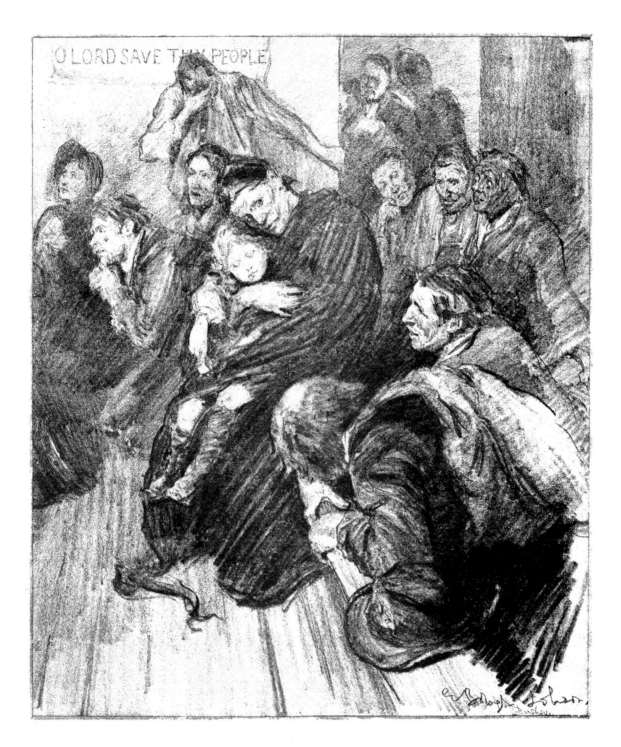

The Refuge. (lead pencil)

PLATE XXIII

Owl Creek Market (Carbon Pencil)

Bought Sketch

PLATE XXIV

would have been hard and unsympathetic, and the roundness and artistic quality lost had the outline of face and head been given with a one-thickness line ; and as a design it would have been a mistake to draw the back of the neck and shoulder. The method of shading is a simple and straightforward one, and expresses all one's needs.

The drawing, Plate XXIII, was made with a broad-pointed BB lead pencil, and is one of the first sketches for some of the figures in my painting of a " Salvation Army Refuge," which I painted in 1891, and which was purchased by the National Gallery, Melbourne. This sketch, drawn in a Whitechapel " Shelter," was produced under trying conditions, owing to a particularly attractive " Lassie " pouring her abjurations into one ear and a beggar gnawing a bone at the other. I trust the fervour of her prayers was reflected in the picture.

CHAPTER V

Outdoor Sketching

GREATLY oblivious of facts, no two artists see the same thing in the same way. It would be dull and monotonous if they did. Where they differ is in the touch and in the rendering of their impressions of Nature.

There is more pleasure to be gained from a good sketch (I won't use the pernicious word " clever ") than from a highly elaborated drawing where little is left to the imagination. After seeing an artist's slight sketch for a picture, in which he has with a few suggestive touches and blotches given us his composition and ideas, we are sometimes disappointed in his finished work, from which much of the inspiration of his first impressions has been knocked out.

I have already referred to an interesting collection of Thomas Girtin's pencil drawings, in the British Museum, which contains views of old Paris, now, alas, like London, rapidly disappearing. These drawings, though highly finished, are all deliciously touched in outline, with no effect of shading—a very difficult thing to do artistically, as all artists know—and yet suggest aerial perspective by strength of touch alone. As we learn, we must work rapidly and with enthusiasm, keenly alive to the beauties of Nature, extracting the spirit of the scene before us : what you will—an old cart, a bit of architecture, street scenes, or anything that appeals to us as worthy of delineating, be it the natural or the human element.

OUTDOOR SKETCHING

The landscape sketcher could find no teacher better than Constable, and it is difficult to believe—if it is true—that Ruskin accused him of being unable to draw. There is a collection of his pencil studies at South Kensington, true studies of Nature in all her moods, which are certainly not pre-Raphaelite in their imitation of little things, but drawing broad and suggestive, seen as Nature really is by this great artist, and not by the camera. We see here lead pencil drawings of tree trunks and their foliage so well drawn and so perfectly understood that they present a valuable lesson to the student of Nature.

The proportions of our paper is the first thing to consider. If a view, how to fill it to the best advantage ; if a low or high horizon, or if a decorative landscape, which is the better, the upright or oblong paper ? All these things the artist naturally feels ; they present but few difficulties. Where the real trouble comes in is where to make a start and where to leave off. Everything depends upon a good beginning. When planning our general composition we must feel our way with long lines, seeing first only the big and fundamental things and arriving at the necessary detail last, never forgetting the darkest accents in the subject, which should be among the first objects to note. Our touch should be free and suggestive, and this can come only from knowledge and the correct pressure of the pencil, held as I have explained. Every subject is good if we render our impressions of it clearly and strongly. The slightest sketch can be strong if it suggests the artist's emotions to others, and the strongest drawing weak if it leaves them cold.

Rembrandt is, from the technical point of view, probably the greatest sketch artist who ever lived, and he is the most human. There are eight volumes of his drawings in the British Museum,

all amazingly clever, with the cleverness of knowledge. Had the lead pencil been in use in his day, what an additional heritage he might have left the pencil draughtsman, even in these days when graphic art has reached such heights of perfection that there is not much to be learned as far as technique is concerned. If I can contribute one little bit towards the understanding and development of the technique of the lead pencil I shall think that I have been justified in placing this book before the public.

When selecting a subject from Nature, the student should always be mindful of the principal object or effect which he desires to express. A knowledge of the rules of perspective is essential; like anatomy, it must not be too insistent, or else it may clog the freedom of our sketch and destroy its sentiment.

The composition of the Arab sheep market (Plate XXIV) was not arranged. I had only to sit down in the blazing sun, ward off the mosquitoes, fight the continual demands for " backsheesh," and sketch as rapidly as possible what was before me, and watch and wait and try to catch some feeling of the natural grouping of the shepherds and their flocks, of which this sketch forms only a part. The general effect of the whole scene was " light," including the olive trees, the darkest accents being the figures. I commenced the sketch at the standing foreground figure, which happened to be there for a few seconds, and trusted to luck for the falling in of the proportions of the landscape, and imitated by contour the general characteristics of the lie of the land and not its individual details.

The Market at Bethlehem (Plate XXV) was a mass of colour and movement, so it was only possible to select some of the

24

In oker Bethlehem. (les Reprises)

PLATE XXV

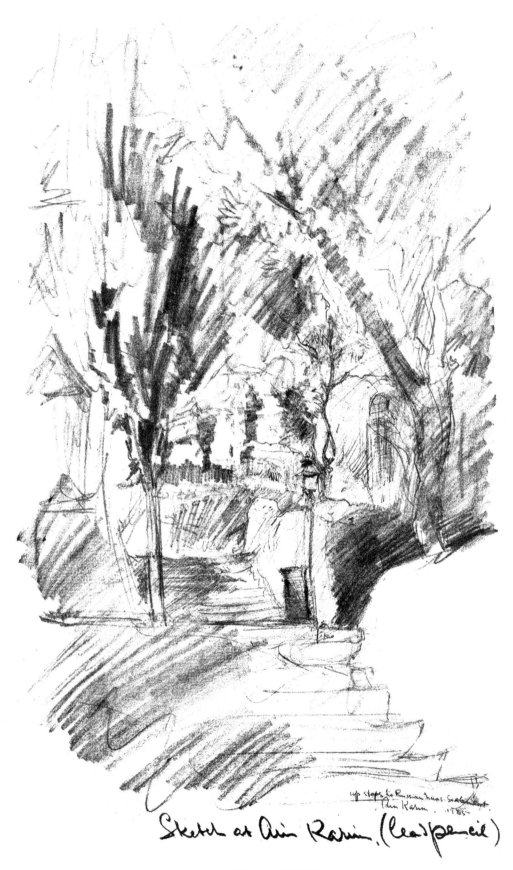

Up steps to Russian nuns. [illegible]
Ain Karin.
1985

Sketch at Ain Karim. (lead pencil)

PLATE XXVI

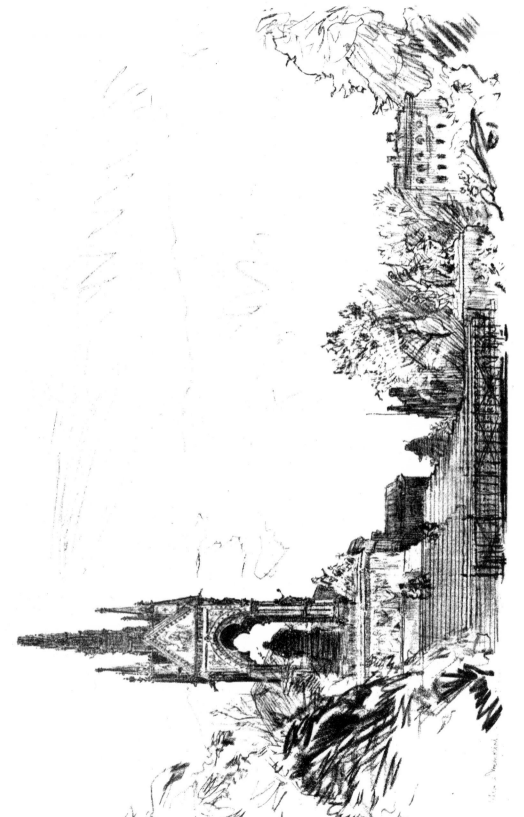

The Albert Memorial (Carbon Pencil)

PLATE XXVII

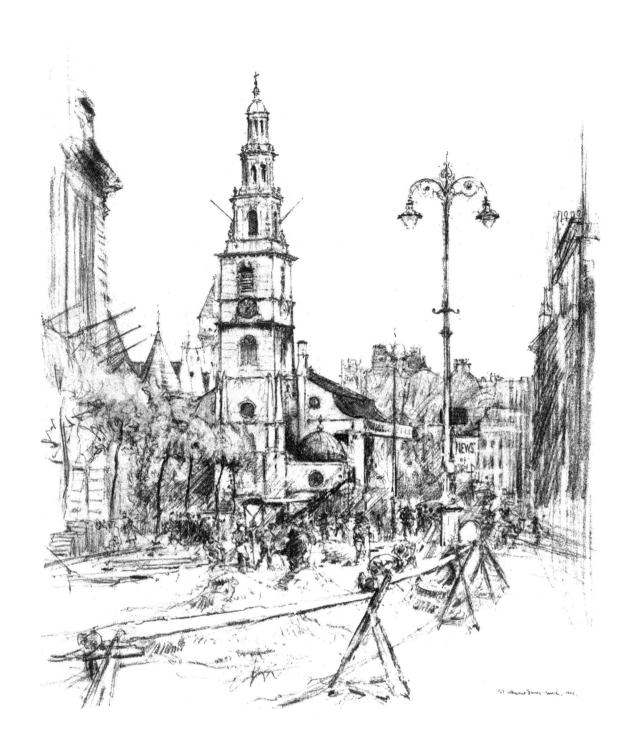

ST Clement Danes Church. 1922.

St Clement Danes Church (lead pencil)

PLATE XXVIII

PLATE XXIX

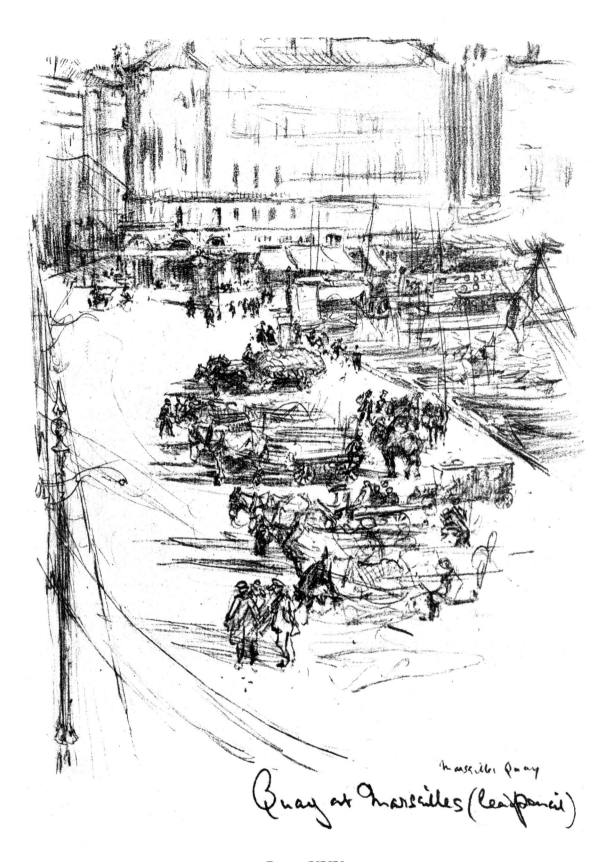

Quay at Marseilles (lead pencil)

PLATE XXX

Wading St. Ogee (Colin Baxter)

PLATE XXXI

The Crown of Olive: Dieppe.
(Plate Peer)

PLATE XXXII

principal groupings and form a design of the impression of the whole, the dark notes giving colour. Studies of life and movement in Jerusalem must be sketched in at red-hot fever heat, almost literally as well as figuratively.

The rapid sketch, Mount of Olives, Jerusalem (Plate XXXII), in lead pencil, is shown for the principal notes—the dark trees, and contour of the hill.

In the sketch at Ain Karim (Plate XXVI) I attempted to suggest in a few moments sunlight and shadow, principally with broad tones. As a contrast to this I give a carbon drawing, highly finished, where I concentrated on detail—the Albert Memorial. St. Clement Danes Church was also necessarily drawn rapidly and with excitement, as I was standing in the street, continually skipping out of the way of the traffic and trying to concentrate on what interested me most, the church tower, leaving the rest more or less loose and suggestive. I include a sketch to suggest a misty morning, the dark note of the figure being important to the effect.

Another sketch of movement, where the eye cannot rest for long upon any one moving object, is that of the Quay at Marseilles (Plate XXX), the distant buildings touched in lightly, the horses and carts more strongly ; no touch being gone over a second time, in spite of obvious lack of detail and other faults, for suggestion is everything in this kind of sketch. The same applies to the clothes-drying scene, in which the washing was blowing in every direction.

I used rather a softer lead, a 4 B, in making the drawing of London Bridge (Plate XXXIII), and finished it bit by bit, from the left-hand side roofs to the right, visualizing the whole scene and how to place it before commencing. The long line

and perspective of the bridge was the most important for the composition. The delicate greys in the distant buildings gradually increased to darker until they reached the nearest arch, where a very broad lead was used. The figures were put in last of all.

The drawing of the Old Church, Honfleur (Plate XXXIV), in carbon pencil, shows sensitiveness of touch with a due regard to the blacks, which help to give colour and light. The buildings on the right and left are sketched in lightly so as to ensure concentration upon the chief interest, which is more in the middle of the picture.

The Damascus Gate, Jerusalem (Plate XXXV), drawn with a 3 B carbon pencil upon a tinted fine canvas-grained paper, is a combination of flat tone shadows with line.

In the study of the old gipsy woman in sunlight, freely sketched, it will be seen that the chief interests lie in the head and hands, the former being highly finished with the point, though not carried so far as in the Italian beggar study, or the Marble Pulpit in the Haram, Jerusalem, which is treated like a pure point etching, careful in its observation of detail; detail not laboriously imitated or insisted upon, but touched in with regard to its characteristic forms and patterns. The distant tower is lightly sketched to take its place in the distance. Sunlight is suggested by the dark foreground shadows and black notes in the arches. Masses of white paper are left for the lights. The drawing was finished bit by bit from the top to the foreground.

I include a drawing of one of the stately buildings of the eighteenth century—the Adelphi Terrace (Plate XXXVIII).

The arrangement is one of vertical lines intersected by

26

horizontal, countered by the curves of the three arches, light and shadow with large proportions of white paper giving the effect necessary to the composition. No rule or plumb line was used, but the perspective was calculated by judging the perpendicular with the horizontal, and by marking the top centre and bottom of the picture before starting the drawing.

I began with the chimney pot, sketching lightly the mass of main buildings, then the oblique line of terrace and balustrades, finally the curves ; to the top again, placing the sloping lines of cornices and windows, judging their correct angles by the verticals. I next put in the darkest notes in windows and arches, then suggested railings, then shadows, and last of all detail.

In the drawing of a tree in sunlight, concluding this chapter, the shadows only are represented by shading, this being all that was necessary to give the effect of what was attempted, namely, sunlight.

CHAPTER VI

Figure Drawing from the Nude : the Importance of Quick Poses

IF we would draw the nude, we must learn to see that the beauty of the human figure is not *only* skin deep, but is dependent upon the structures underlying it, including the working mechanism of the separate bones, a scientific problem most difficult to understand, more especially when we have to represent a solid form on a flat surface.

Blessed with good eyesight, many can judge a straight line correctly. A square as a square, or even a perfect circle, is obvious to our vision, but few can see a long curve accurately. As the fleshy forms of the human body are practically all convex curves, markedly so in the female form, the difficulties of drawing it are manifold.

Writing principally for the benefit of those who have advanced beyond the rudiments of art and have acquired facility of drawing stationary objects with more or less readiness, I have felt it unnecessary to enlarge upon the elementary and progressive subjects of a draughtsman's training. These do not enter under the title of this book. As figure drawing from the life is the final stage in the technique of the pencil draughtsman, we can become masters of execution only with much pain and continual application, added to some knowledge of anatomy and proportion—the more the better, so long as it is not misapplied or paraded. Otherwise, without even a superficial

28

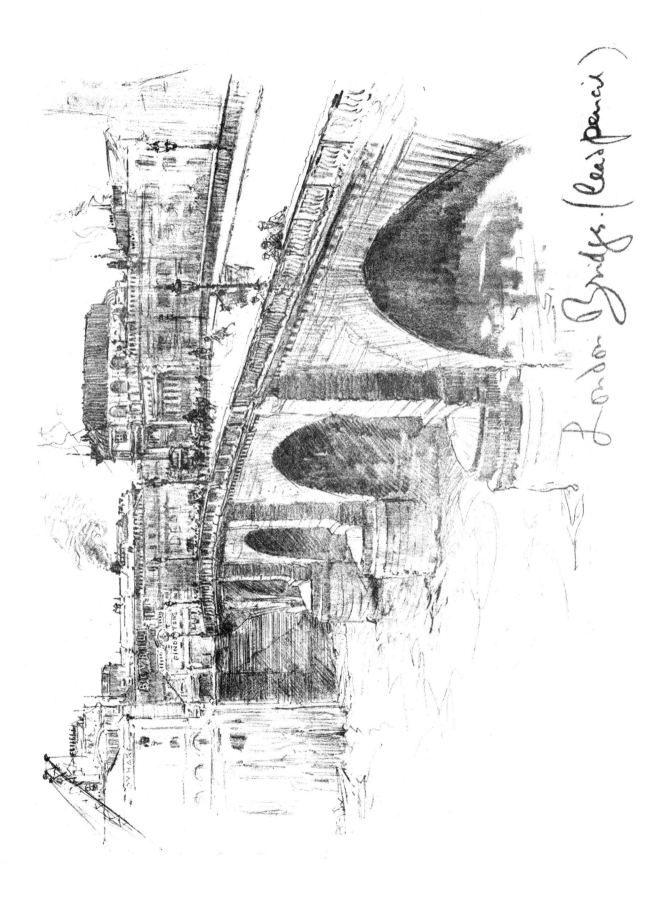

London Bridge. (Lead Pencil)

PLATE XXXIII

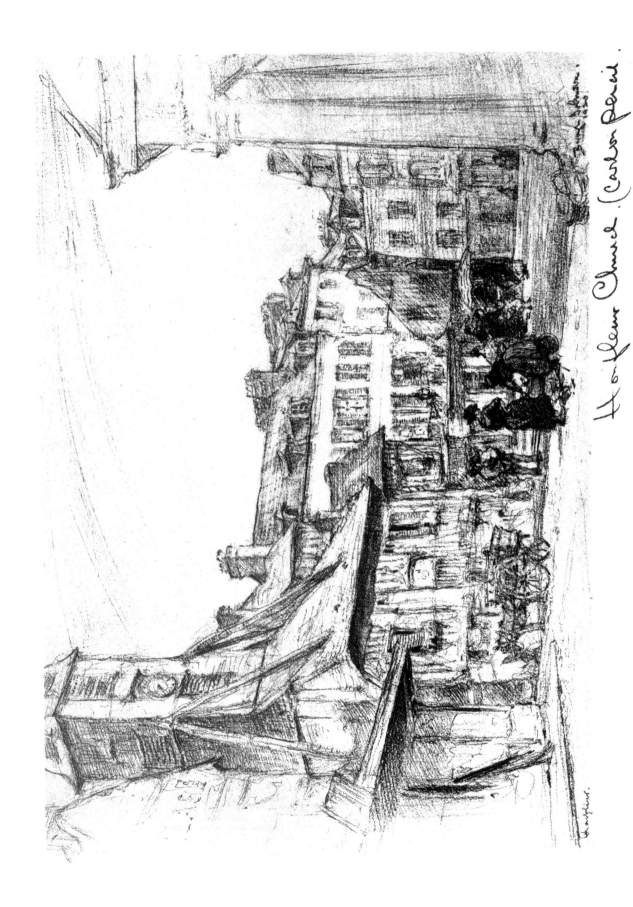

Honfleur Church. (Carbon Pencil.)

PLATE XXXIV

Damascus Gate, Jerusalem (Carbon Pencil)

PLATE XXXV

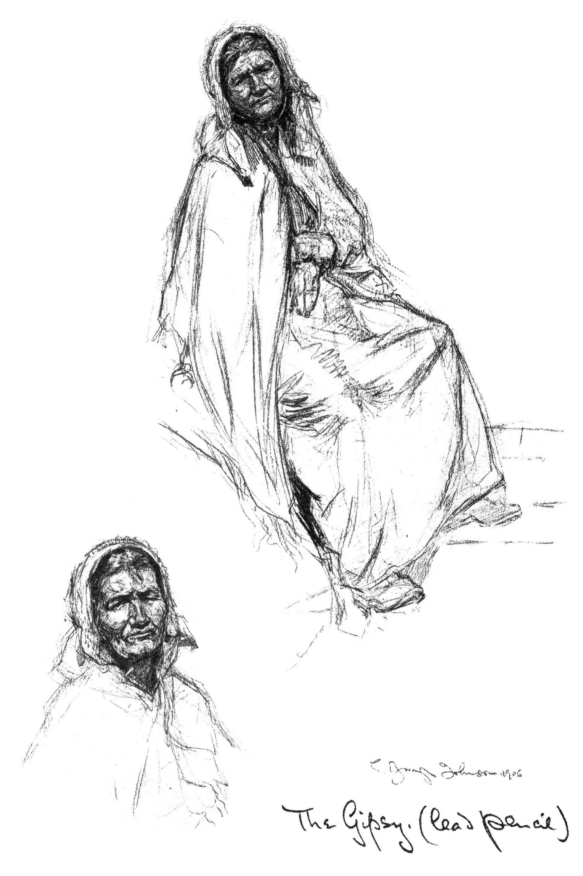

The Gipsy. (lead pencil)

PLATE XXXVI

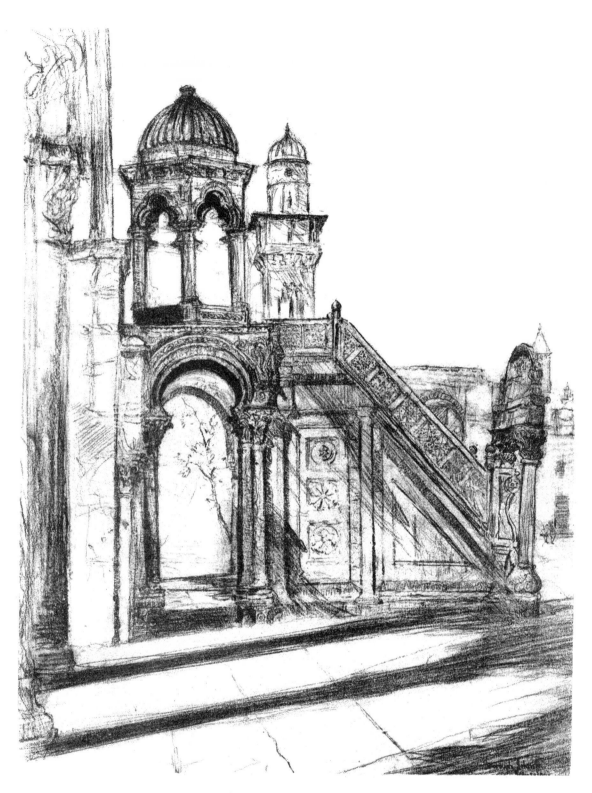

Marble Pulpit in the Haram, Jerusalem.
(Carbon pencil)

PLATE XXXVII

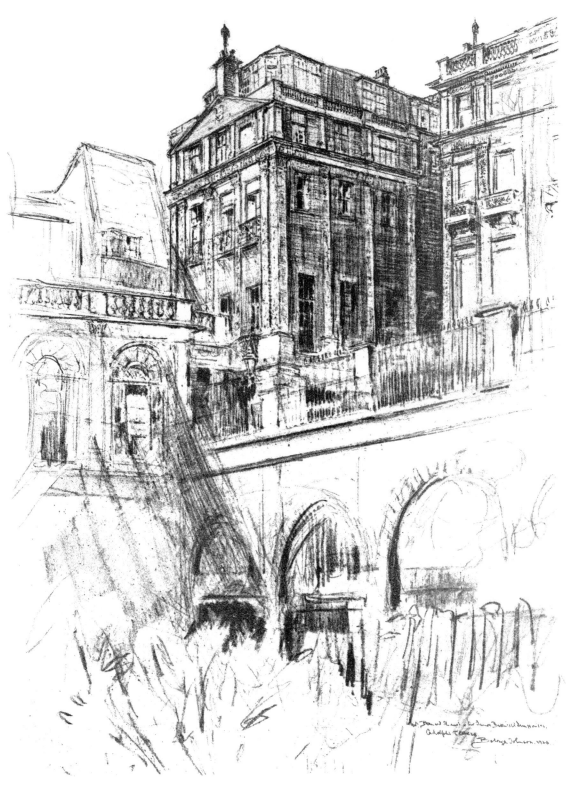

Adelphi Terrace (pencil & charcoal)

PLATE XXXVIII

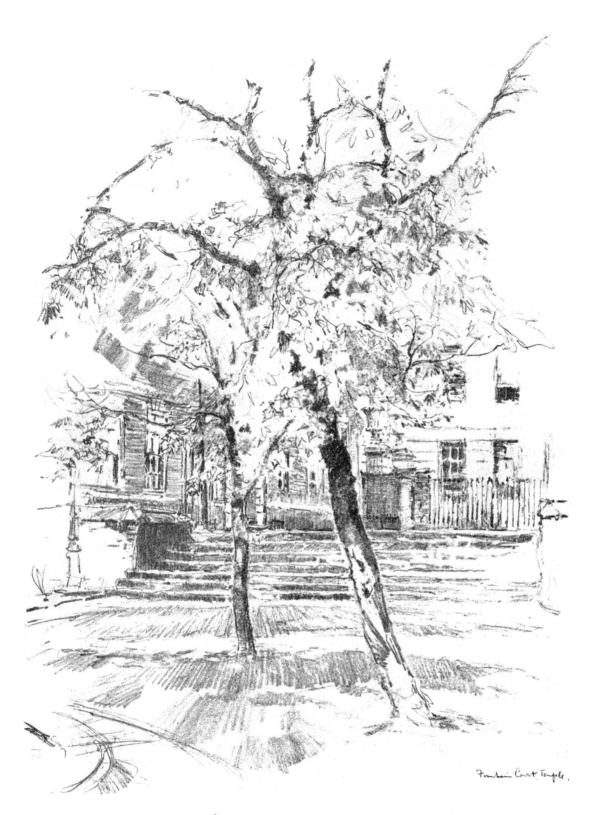

Fountain Court Temple.

Trees in Fountain Court (lead pencil)

PLATE XXXIX

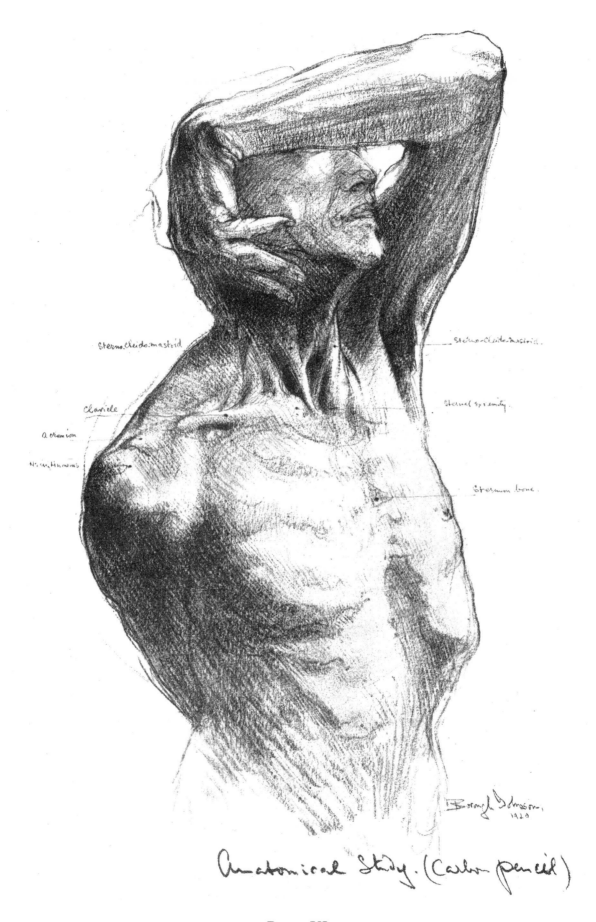

Sterno-Cleido-mastoid

Sterno-Cleido-mastoid

Clavicle

Sternal extremity

Acromion

Neck Humerus

Sternum bone.

Brough Johnson.
1920

Anatomical Study. (Carbon pencil)

PLATE XL

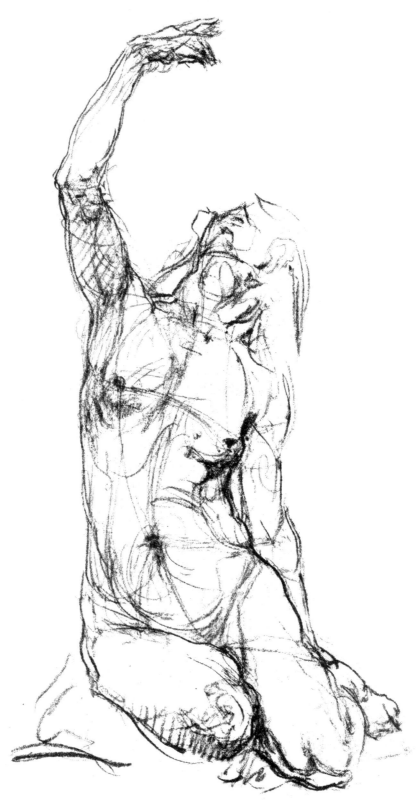

Ten minutes pose. (chalk)

PLATE XLI

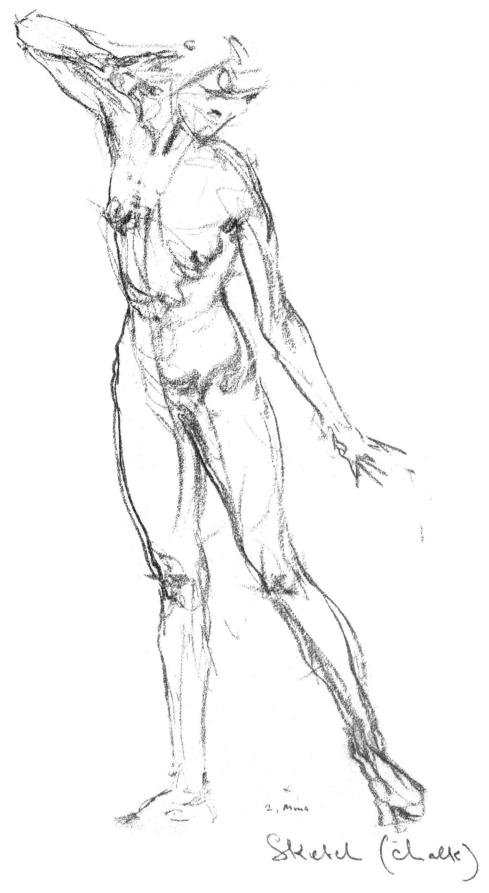

2, Mme

Sketch (chalk)

PLATE XLII

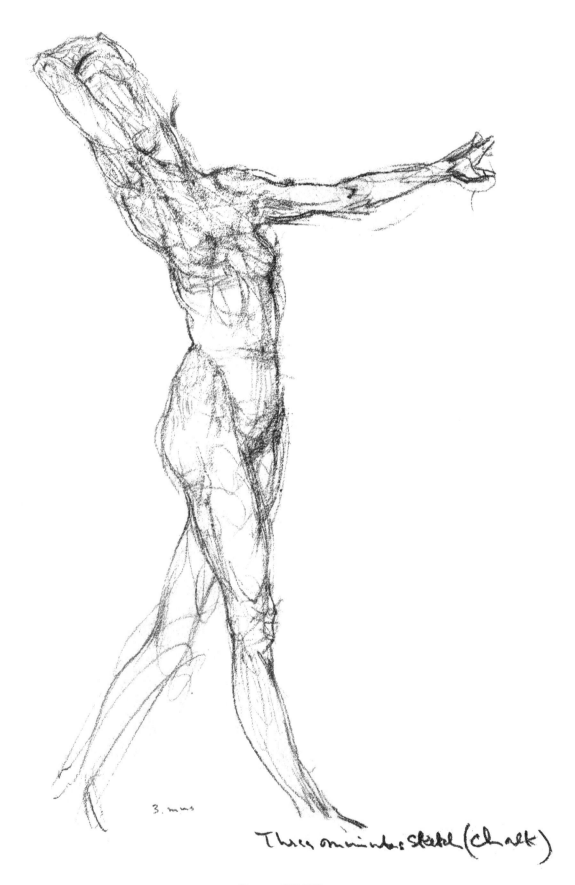

3. mus

Three minutes Sketch (chalk)

PLATE XLIII

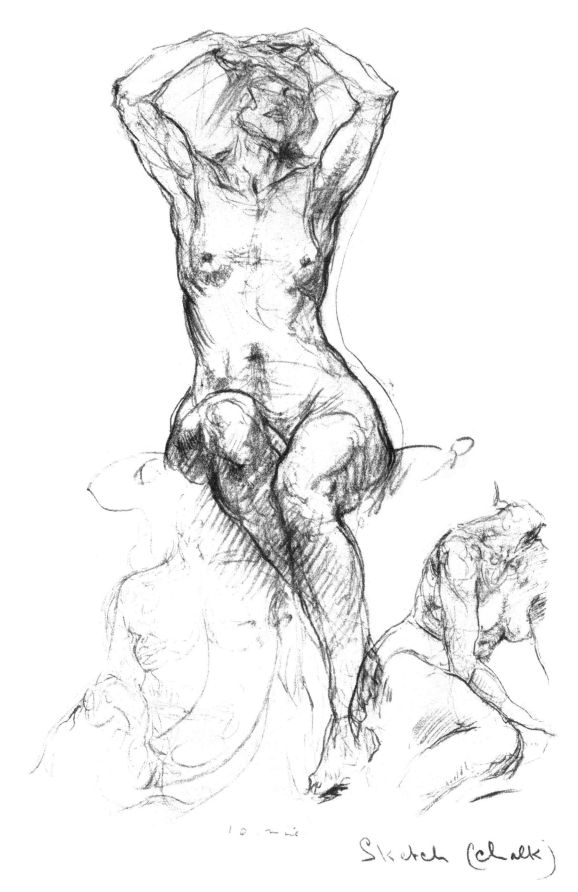

Sketch (chalk)

PLATE XLIV

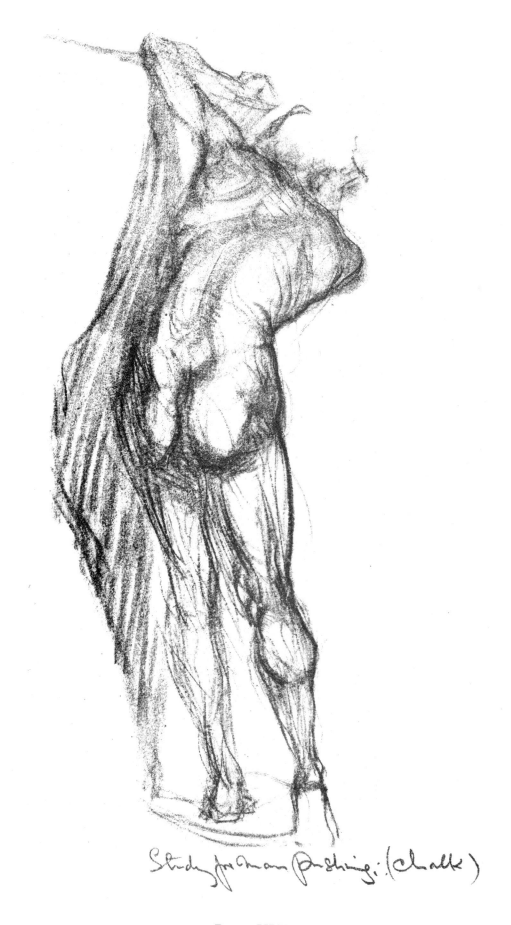

Study for man pushing. (chalk)

PLATE XLV

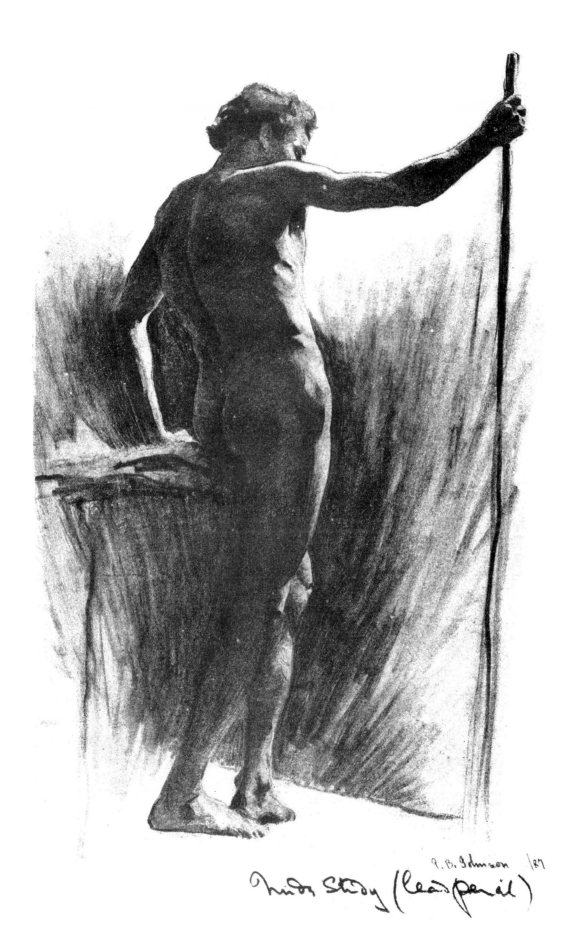

Nude Study (lead pencil)

PLATE XLVI

acquaintance with these two sciences, it is hopeless to attempt the most exacting and elusive of all subjects requiring concentration of the mind, eye and hand, all interacting in unison. Before we can draw with knowledge and freedom, we must copy the studio model intimately, with scrupulous exactness both in action and at rest, make many careful drawings of bones and muscles that come into evidence under action or strain, such as the study in Plate XL, showing the neck muscles and the bony prominences of the forearm joints and shoulder, and learn to see our own faults rather than have them pointed out by a master ; for it is not very instructive for a teacher to show students mistakes of proportion which should be self-evident to them on reflection. When we have attained this ambition of seeing correctly, comes " expression," that is, the artistic view, which will take care of itself provided we have the artist's vision.

As I believe the ultimate end of a figure draughtsman is to attain, with the least possible manual labour and with the avoidance of unnecessary details, the complete impression of the whole, shown principally by the contour or outline, I shall endeavour with this principle in my mind to illustrate my belief with the accompanying reproductions of quick poses from the nude, made specially for this book, never forgetting that to arrive at freedom we must progress slowly through the mill of grinding, close study, and, to the serious student, many bitter disappointments.

Our aim in quick poses such as I introduce in this book must be a more or less condensed and intelligible conception of the figure in contour, with the inner modelling suggested merely by a few salient touches indicating the bones and prominent muscles, which will be sufficient to give solidity to the

figure, a fact which should be ever present in the memory, for form is the first matter in drawing the nude.

Simplicity, balance, character, direction and relation of the limbs to each other, with their proportions and general symmetry of the whole, must be apprehended in a flash and put down in long lines, without lingering on less important details of form, for there is little time to hesitate in making a ten-minutes sketch. The quicker we draw, the better, so long as we can keep up the tension of our eyes, brain and hand all working together at the same time. The moment one of these three faculties gets out of gear or tired, the vitality of the drawing is lost. An intelligent model in a good pose inspires us enormously to produce an artistic and living drawing. A drawing done in a few minutes, in a red-hot fever of excitement and with concentrated observation, following the contour of the form from start to finish, is far more living than the often elaborated drawings of a cataleptic, relaxed figure, dumped upon the traditional throne, so often seen in art schools; for the essence of life figure drawing lies in the outline. There is no short cut, no royal road to excellence: the only way is by persistent study and cultivation of visual memory.

Rapidity of execution is often used to disguise ignorance and emptiness. That is of no use to the serious student. However brilliant the handling of a life drawing may be, without a sound foundation of anatomical construction the result must be fundamentally superficial and valueless. Much more is drawn in the mind than the hand can depict, for there is always the other side of the figure and its separate parts which we cannot see, but which we should know, always searching for form, yet never losing sight of the figure in its entirety. Once let us

30

grasp this maxim, impressed upon me by my first master, Professor Legros, and good draughtsmanship will result. To the real draughtsman faulty drawing is as painful as a voice out of tune is to the musician. "Drawing stands for honesty in art," and by "faulty" I mean, of course, drawing that suggests no structure.

There can be no finality to the study of the human figure. An ordinary literal statement of facts is not art, though it may be brilliant technically. As François Millet said, "in order to see it is not sufficient merely to open the eyes; there must be an act of the mind." The bigness of his drawings proves his words, and shows that originality comes from truth to Nature, rather than from a non-observance of her principles.

In common with most artists, I feel that drawings which are free and simple in their methods, and not over-elaborated in tone or shading, generally display greater inspiration and vitality than more highly finished work. Observe the pen and bistre drawing of "The Bather," by Michael Angelo, in the British Museum, with its resistless and grand outline. High finish need not necessarily imply tedious elaboration, but more often than not an excess of minor detail wearies the eye, and weakens the effect of the constituent parts, thus detracting from the unity of the drawing as a whole. On the other hand, an insistence on line and contour more readily and effectively expresses a fact in large manner by delineating a rapid impression of a condensed and intelligible idea.

We can see at the Victoria and Albert and British Museums large collections of drawings and studies from the nude in red chalk and pencil that Alfred Stevens invariably followed the curvature of the forms in his method of shading, employing a distinctive style of his own. These drawings are a source of

learning which cannot be over-estimated. This master, a star of the first magnitude, rising at a time when in England applied art was stagnant, revived the spirit of the Italian Renaissance in this country when art sorely needed it. This great Englishman was no plagiarist, though he showed what he had learnt during his sojourn in Italy from the great Florentine, Michael Angelo, his master.

Teaching drawing by the written word presents many difficulties to the artist, for the experience of years cannot be imparted offhand. Practical demonstration is so much better for emphasizing his meaning and for correcting faults. This being so, the figure studies illustrating this chapter may atone for the shortcomings of the text and prove useful to the student.

The sketch in Plate XLI is drawn with chalk.

Commence from the index finger, stop at wrist joint, feeling the bone, down again to elbow, emphasizing the joint, on without a stop to hip (iliac crest), then to knee; start again from finger tip, indicating the hand, on to end of forearm, indicating the bony protuberances of joint; then line of biceps, deltoid, neck and head suggested. Return to left pectoral muscle and breast, which, being a soft edge, is drawn with a wider and softer touch. Mark in mind position and placing of nipple with its opposite; indicate lightly curve through centre of body from neck centre to termination of trunk; then draw right side as far as wrist, accenting the line on hip, which appears sharp; back to right shoulder, lightly touching in arm, which recedes; place umbilicus correctly by judging angles and directions, then upper line of left thigh and knee, then bottom of right knee, losing line of leg, which is not seen, then finish contour with foot. Shadows and inner forms should be suggested last of all.

FIGURE DRAWING FROM THE NUDE

In Plate XLIII, a three-minutes sketch, three long lines compose the figure, viz., a sweeping curve from left hand to right elbow, a long curve from forehead to back heel, and an oblique line through the figure, starting from the neck and falling on front of thigh and beginning of foot. These lines must be imagined before the drawing is started. Sketch the outline quickly, commencing from left hand, with soft and sharp touches as edges are felt, proportions and balance kept constantly in the mind, inner modelling suggested with a broader and lighter touch. Ignore the smaller features.

The two-minutes pose shown in Plate XLII was drawn at express speed without a stop, to give the momentary action, this being all that is necessary for such a study.

I drew the three-minutes' study shown in Plate XLIV in the same manner as that in Plate XLI, to show the obvious decorative curves pervading this figure.

The quick study of a man pushing against a door (Plate XLV) shows the effect of lost edges against those sharply defined by the foreshortening of the upper half of trunk. It will be seen that the muscles of the right leg are brought into action. Long sweeping lines with the shading take the direction of the forms, thus adding to the movement of the figure, the shadow side being suggested by a few broad and loose strokes.

For the last illustration to this chapter I give a pencil study from the nude, drawn by myself when a young student. Though it is trite and " worried to death," its defects may serve to suggest how much conscientious patience and close observation are necessary to gain anatomical knowledge and ultimately to arrive at simplicity, vitality, and artistic touch.

CHAPTER VII

Observations on the Proportions of the Male Human Figure

LEARNED treatises on art anatomy are somewhat dry and abstruse in subject-matter unless seriously studied side by side with the skeleton and life model. The true representation of the human figure, to which the student's mind should be primarily directed, has always presented the greatest difficulty, for anatomy is purely a scientific study founded upon definite facts. Of these proportion is most important, that is the relative size of the various parts of the body in length, depth and width as composing the figure in its entirety.

Without cultivation of the memory, keen observation and a knowledge of the separate bones, muscles and planes seen in comparison with each other, we cannot draw the figure with any satisfaction. As it is from the bones and their surface prominences that we register our measurements, a sound knowledge of the skeleton is indispensable.

The recondite nature of this subject, with its many technical applications as propounded in most anatomy textbooks, with their numerous diagrams, facts, figures and units of measurement, is apt to confuse and prove tedious. There is no sure foundation on which to build a system of proportion adaptable to modern man. One cannot confine proportion to rules which will be of practical use to the present-day draughtsman, and there is but little in textbooks to rouse the art student's

34

emotions. Close study from the living model, seen in many attitudes of movement and rest, is essential.

It is a moot point whether the ancient Greek sculptors acquired their knowledge of the human body by systematic post-mortem examination. The greater probability is that they gained their superlative symmetry of form, with marvellous anatomical exactitude, from constant and intelligent observation of the superficial muscles of the living man as seen by them in everyday life, at games and athletic exercises, where wrestling, which formed an important part of an athlete's training, brought all the muscles of the body into action, and that the sculptors relied more upon the eye and memory than upon scientific investigations. These supreme artists took a real type of man, perfect in all his proportions, such as the " Fighting Gladiator " —and no doubt many of the athletes of those days were as well formed—and did not create the ideal, as we understand it, by selecting the best from imperfect manhood.

Modern artists are handicapped. We have not the advantages of the ancient Greeks of observing unclothed man in action. Movement can be studied thus only, but we have no Grecian games, nor the climate in which they could be held. The cinema might be educative in this respect, and will, I hope, one day be used in art schools for this instructive purpose. For us it would be absurd to try to idealize an ordinary school model, which is usually misproportioned in some part or other, notably in the bones of the feet, into the perfect form of a gladiator or a Venus de Medici, or to apply the ancient canon of Polyclitus to the modern figure.

Mechanical measurement upon the living model is of little value, owing to the diverse types and manifold differences of

figure, and perspective and foreshortenings throw one entirely out. The eyes are the only sure means of attaining to good proportions. The artist must seize upon the essential points and use his powers of observation to the utmost, calculating the exact distances between the various bony protuberances and divisions, and at the same time fixing the principal characteristics in his mind.

As I have already said, accuracy in portraying the main superficial proportions of the human body can be acquired only by a close study of the skeleton, its joints and their mechanism, and by assiduously drawing the life model under varying conditions of movement. This, in time, should ensure real progress in the education of the eye, memory and hand, leading by much practice to a certainty of manipulation and individuality of handling which will give distinction of " style " to the drawing. This desirable quality, personality in expression, to be of any true worth, can be arrived at only by the mechanical stage preceding the ultimate artistic presentment. Sight is so instantaneous, taking in at one glance innumerable colours, masses and shapes, with their infinite details, that it is impossible to fix the attention upon the whole form and at the same time see every part equally well. Therefore it follows that all the members and forms of the life figure should be separately studied, in proportion to each other, so as to provide a complete harmonious whole consistent in its type of individual, the model being studied " mentally " before the drawing is started. The student should concentrate sight and memory upon the type and characteristics, the important essentials, eliminating the smaller details, and understand every part before comparing it with the rest.

THE MALE HUMAN FIGURE

The dimensions of the human form should be considered principally in lengths and divisions, and in halves; that is, the whole of the head into cranium and face, trunk into chest and abdomen, upper limb into upper and fore arm, lower limb into thigh and leg, extremities into palm and fingers, arch of foot and toes, and so on, after which these can be bisected longitudinally, to enable the student to observe the balance of weight and similarity and dissimilarity of inner and outer contours, and so obtain a clear notion of the true shape of each individual part.

The inexperienced student should, in the first stage, start his drawing in a free, sketchy, structural method, defining the constructive lines, that is, the scaffolding of the figure, using long strokes without too many curves, and by this means getting the parts to hang well together, for all the members must correspond to the whole. The vertical line of gravity, found by using a plumb line, should be first placed on the paper. Bisect this line to find the centre of the figure, considered vertically. The point of bisection will be in the lateral plane of the pubic bone and the great trochanter. Then mark with transverse lines the direction of the pelvis or hips, waist, shoulders, knee joints, feet, etc. Proportions can only be approximative, and it is not my intention to try to present a new system or a short cut to gain accuracy, but chiefly to rely upon Nature and intelligent study, helped to some extent by a few practical hints which may prove useful to the inexperienced draughtsman.

A system I have found useful for arriving at general proportions, founded upon a few simple reasonings and geometrical deductions, consists of imagining straight lines from

point to point at various parts of the model, taking a right angle as a basis. It is useful for the student beginner actually to mark the lines upon his paper. Thus, to give a simple example, should the figure be standing erect, with both arms extended horizontally to the body, the point of intersection between a line drawn from the top of the head to the finger tips, and another line from the little toe meeting the above, gives the true linear proportion of the outstretched arm, provided the degree of the angles has been accurately found (by holding a pencil, with arm extended, to the points taken on the model and then to the drawn lines to see if they correspond exactly—and a steady hand can do this). This method can be applied to all parts of the figure with useful results. It is easier for the eye to follow the direction of a straight line, on whatever angle it may fall, than to judge the direction of a form or member, say a limb, with its numerous modulations of convex curves and subtle contours. Thus, in a measure, we lessen the difficulty of measurement, perspective and foreshortenings, always a despair to the beginner and a trial to the figure draughtsman, even if he be accomplished. We may get a better idea of proportion and gain a bigger conception of the figure if we continually vary the size of our drawings, from small to large, and *vice versa*, even, when possible, making life-size studies as is done in some German schools. We can see our faults on a small scale more quickly than on a large one. Owing to the range of our sight, we cannot focus and compare a life-size figure drawing with the model unless we see them together at a sufficient distance to take in the whole aspect at one glance.

There are a few well-known measurements of the human body which at times may prove useful to the draughtsman,

38

though, of course, he will find it impossible to make all his figures conform to a convention. In a well-proportioned male figure of 5 ft. 10 in. in height, equal we may say to $7\frac{1}{2}$ heads in linear measurement, the model standing erect, we find that the head from top of cranium to underneath the chin measures 9 in., the second head will arrive at the nipples, the third at umbilicus, the fourth bottom of trochanter, fifth well above the knee, the fifth and a half head through the knee joint, the sixth well below the patella, seventh above the ankle joints, and the seventh and a half at the heel. The total length with foot extended, or standing on the toes, is eight heads. A horizontal line drawn through the fourth measurement will give the horizontal middle plane of the figure, at the end of the trunk, whilst the fifth and a half division marks the half of the lower limbs. Of course, this formula proves only of real value when the model is erect and of the given height. Any foreshortenings of the head, trunk or lower limbs will throw the student out of his reckonings, and will allow for no defects or unusual characteristics of figure as frequently met with in man.

The ancient Egyptian canon took the length of the middle finger as being contained nineteen times in the whole length of the male figure.

We may read in Vitruvius, an ancient Greek writer four hundred years posterior to the best period of Greek Art, the following words—though we must take into account that some of his own measurements are erroneous, and could not be applied to living man—

" Nature, in the composition of the human frame, has so ordained that the face from the chin to the highest point

of the forehead, whence the hair begins, is a tenth part of the whole stature. The same proportion obtains in the hand, measured from the wrist to the extremity of the middle finger. The head from the chin to the top of the scalp is an eighth, and as much from the bottom of the neck. A sixth part is given to the distance from above the chest to the highest point of the forehead; and from the same point to the top of the skull, is a fourth of the whole stature."

If the length of the face from the chin to the roots of the hair be divided into three equal parts, the first division determines the place of the nostrils and the second the point where the eyebrows meet. The foot is a sixth part of the height of the entire frame; the cubit and the chest are each a fourth.

The other members have certain affinities which were always observed by the most celebrated of the ancient painters and sculptors, and we may look for them in those productions which have excited universal admiration.

The navel is naturally the centre point of the human body, for if a man should lie on his back with his arms and legs extended, the periphery of the circle which may be described about him, with the navel for its centre, would touch the extremities of his hands and feet.

The average height of a woman is 5 ft. 3 in., with a head of $8\frac{1}{2}$ in. in length. The palpable differences of proportion between the sexes are seen at the waist, pelvis, thigh and length of arm. These formulae are interesting to the scientific student, and perhaps at times may be helpful to the beginner in life drawing, but it may be wiser not to rely upon " systems

of proportion," and to leave alone conventional canons, however ingenious or theoretically exact they may seem to be. They can only be really valuable when taken in conjunction with close study of the living model, demonstrated if possible by anatomical dissections and practical lectures on the figure by a competent artist anatomist. Personally, I have never made use of any such " rule," nor have I in former years advised my many thousands of " life students " to do so. Rules would distract me too much and put me, so to say, off my stroke. Keenness of vision, with knowledge gained by practice, is all sufficient for the average good draughtsman. What is of far more value is the frequent study of drawings by the great masters, Michael Angelo, Leonardo da Vinci, Raphael, Durer, etc.; above all, the first-named artist, whose figure studies and modellings are a mine of information and inspiration to those who are artistically endowed and can appreciate genius.

Leonardo, that great thinker, to whom nothing was too little or too great to investigate, has left us a canon of proportions, with an enormous mass of information, with numerous drawings of anatomical dissections, in his treatise on anatomy, *Quaderni d'Anatomia*, six volumes, a work to which during his long life he gave many years of exact study. Some of his deductions and measurements (vol. vi) are, however, often difficult to understand, and cannot always be taken as conclusive evidence.

In many of his figure studies Michael Angelo adopted no hard and fast normal standard of measurement, but conceived man and woman according to the emotional or impetuous mood by which he was at the time possessed, feeling and making

others feel by his interpretation of forms and expression to an extent no artist has perhaps ever equalled. He, with many of his contemporaries, was frequently deficient as regards academic preciseness as to facts, and paid little attention to conformity with rules. The student must keep to facts and Nature until he is competent to draw as well and as freely as his temperament directs him; then he may fully appreciate the intellectual as well as the more imitative qualities in the drawings of the great masters.

A GALLERY
OF
MISCELLANEOUS STUDIES

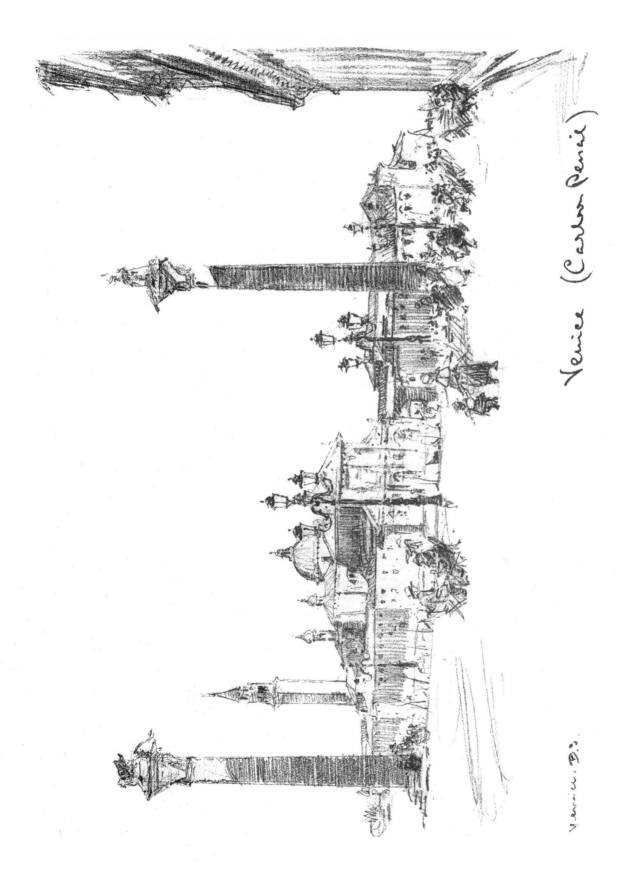

Venise (Carlo Renié)

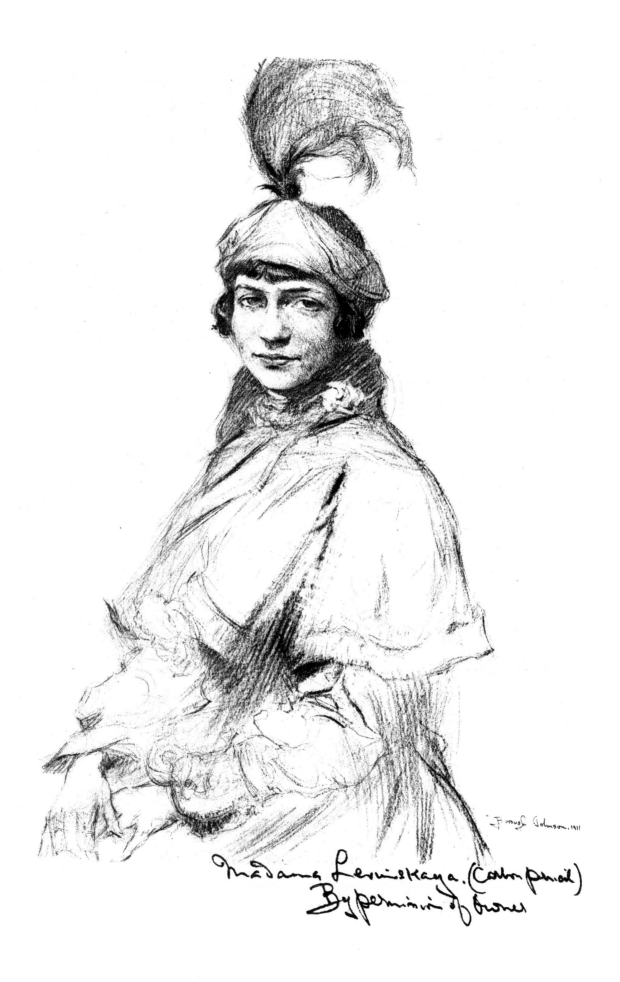

Madama Levinskaya. (Colour pencil)
By permission of owner

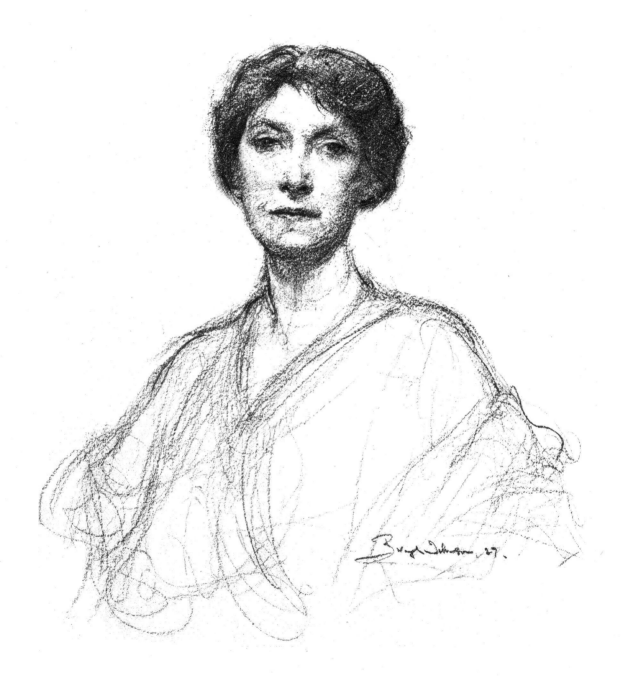

Mrs. Louis Fenn. (chalk)
By permission of owner.

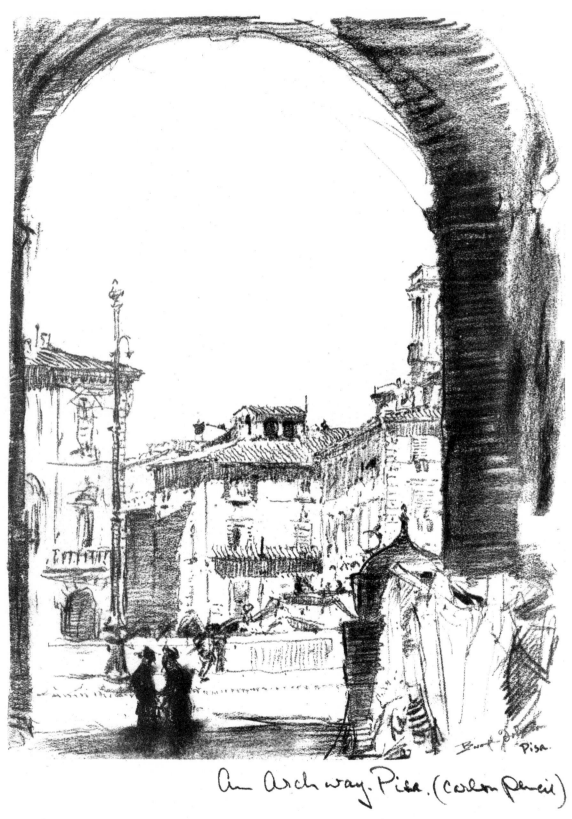

An Archway. Pisa. (carbon pencil)

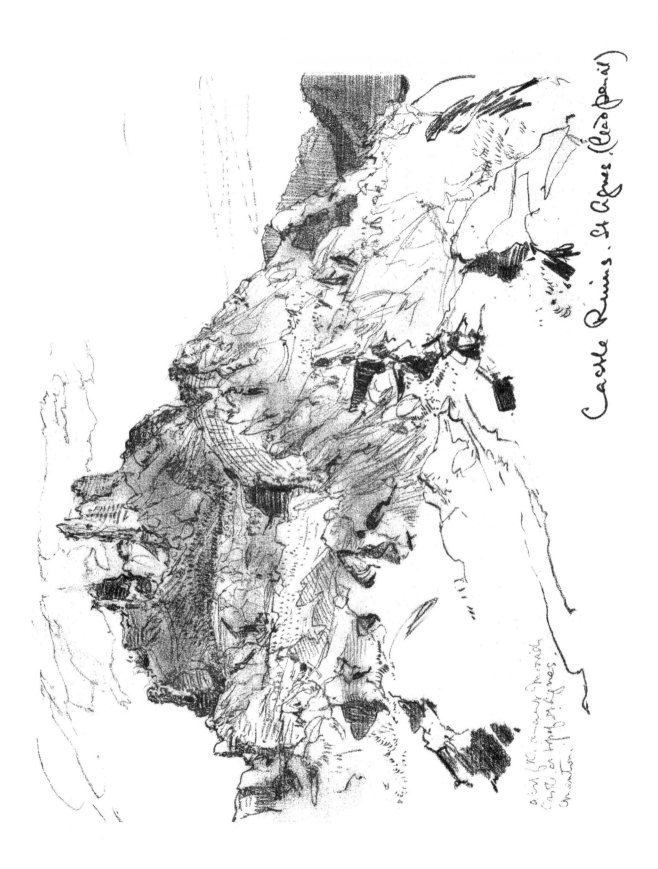

Castle Ruins. St Agnes. (Scilly Isles)

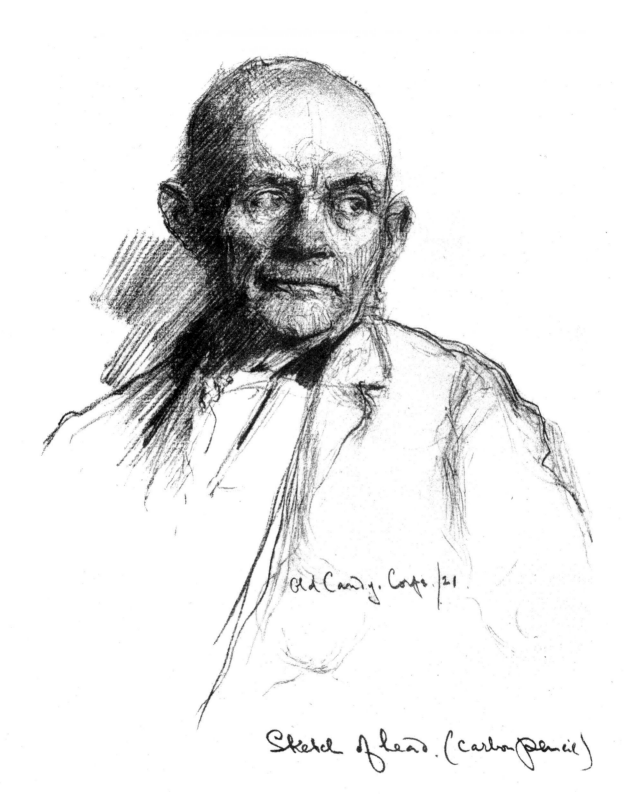

Old Candy. Corps./21.

Sketch of head. (Carbon pencil)

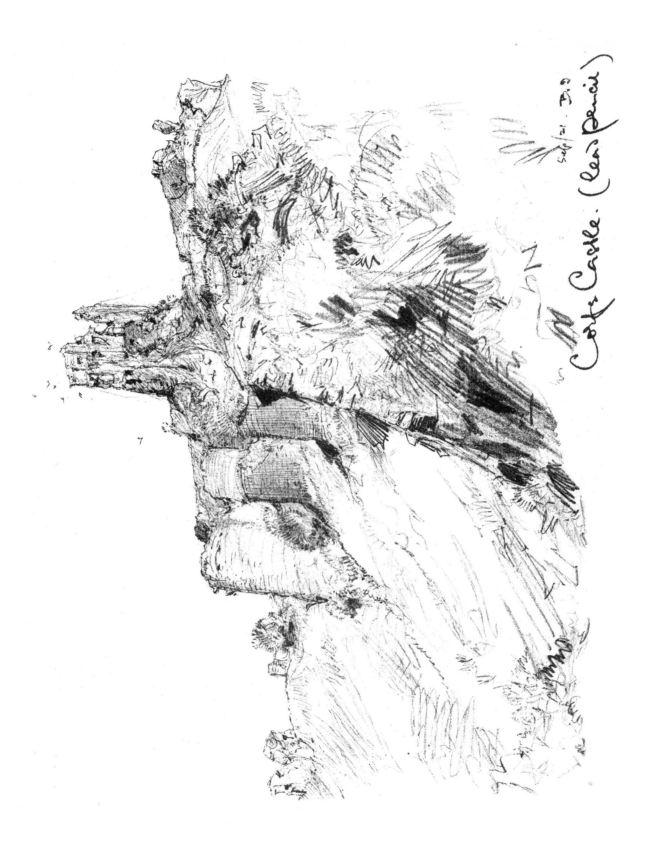

Corfe Castle. (lead pencil)

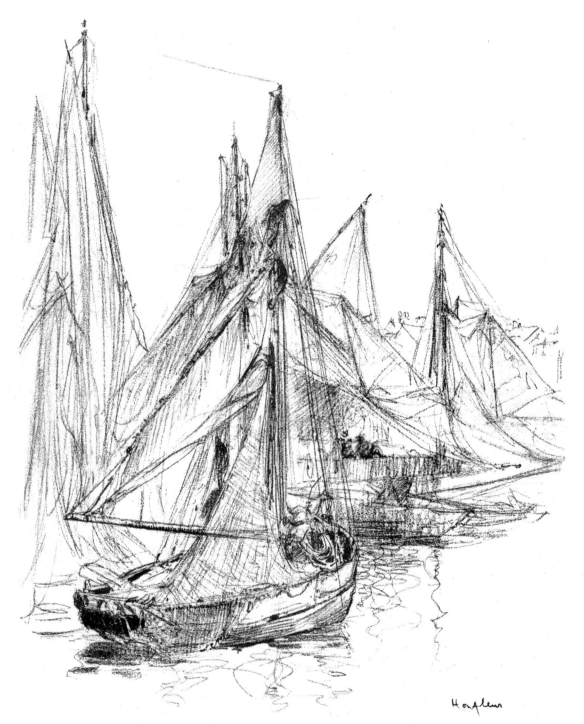

Honfleur

Boats at Honfleur. (Carbon pencil)

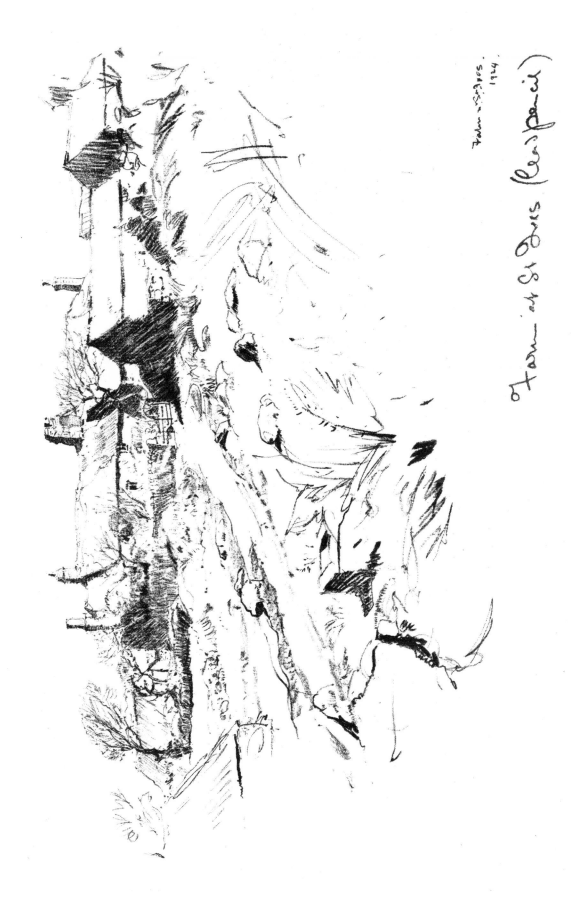

Farm at St Ives (Pen pencil)

Farm at St Ives.
1914

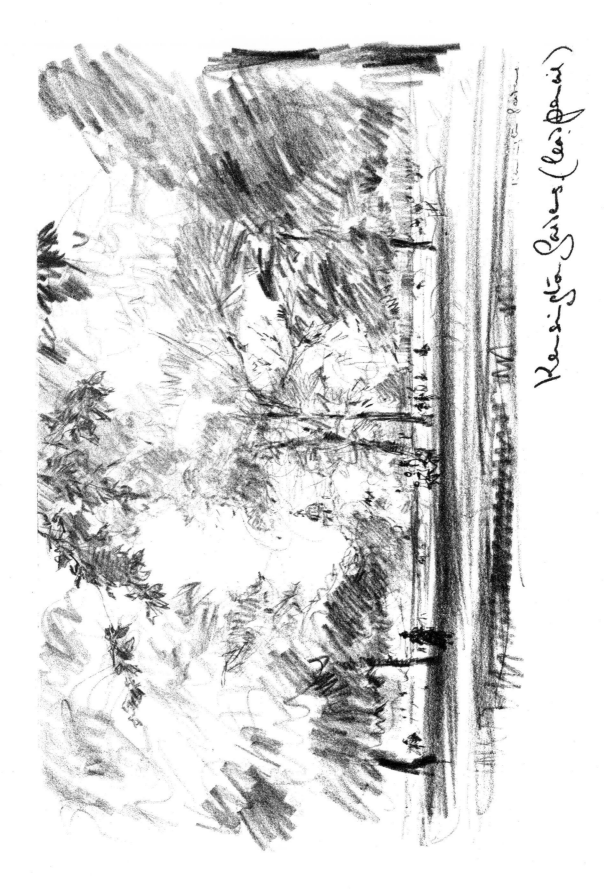

Kensington Gardens (last again)

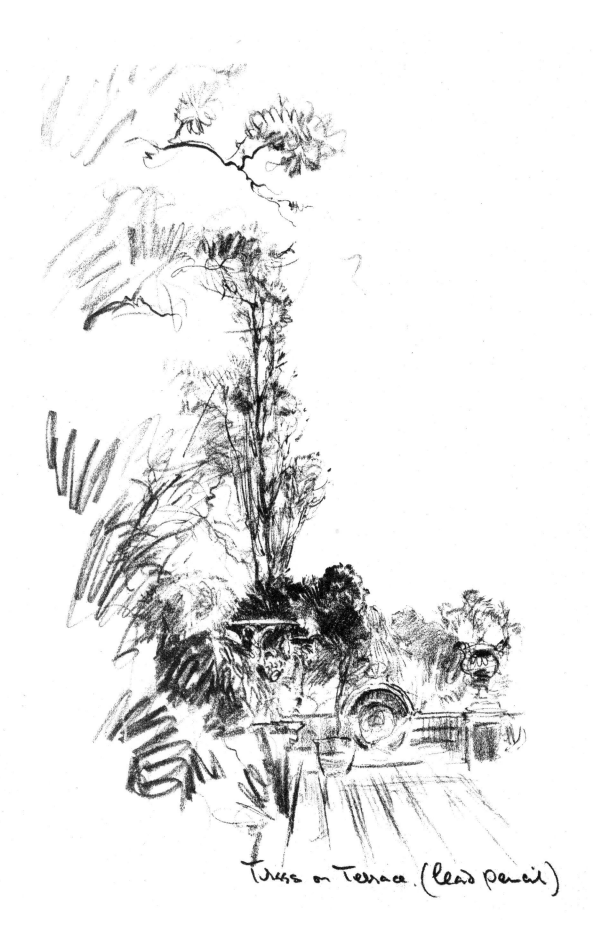

Trees on Terrace. (lead pencil)

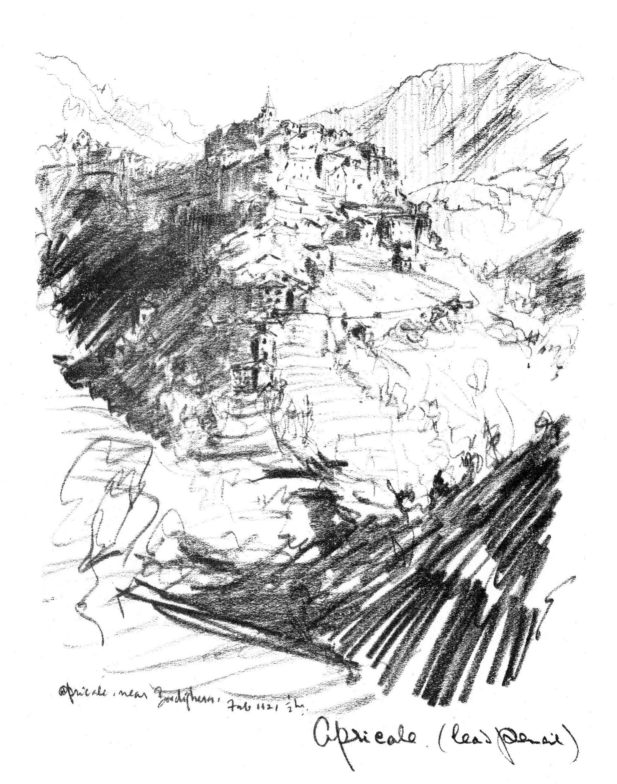

Apricale, near Bordighera, Feb 1121 ½hr.

Apricale. (lead pencil)

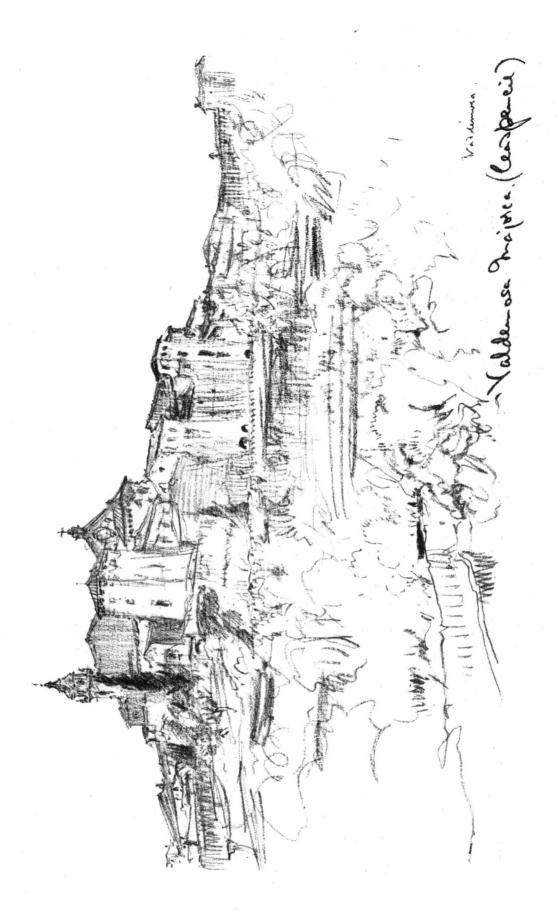

Valdemosa Mallorca. (Cartopici)

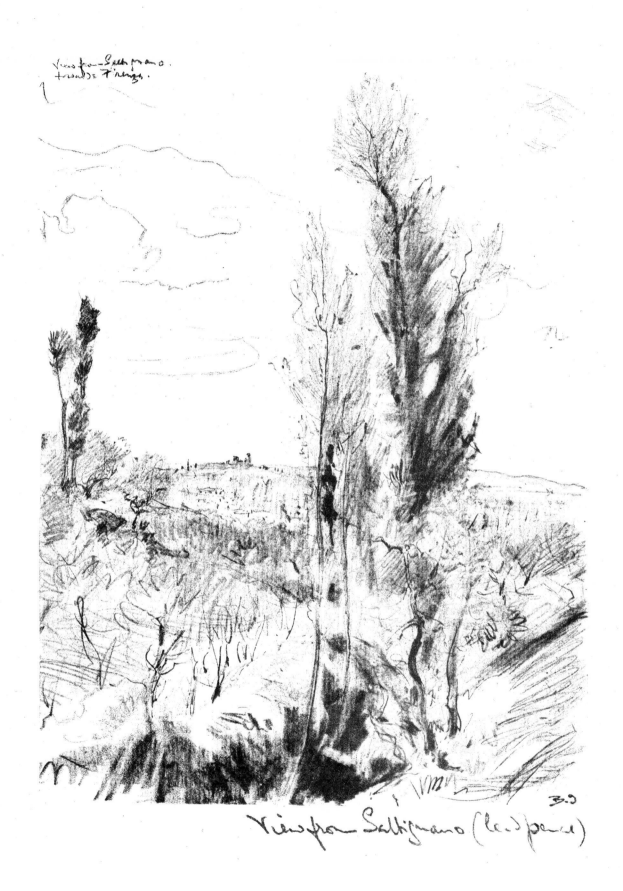

View from Settignano (lead pencil)

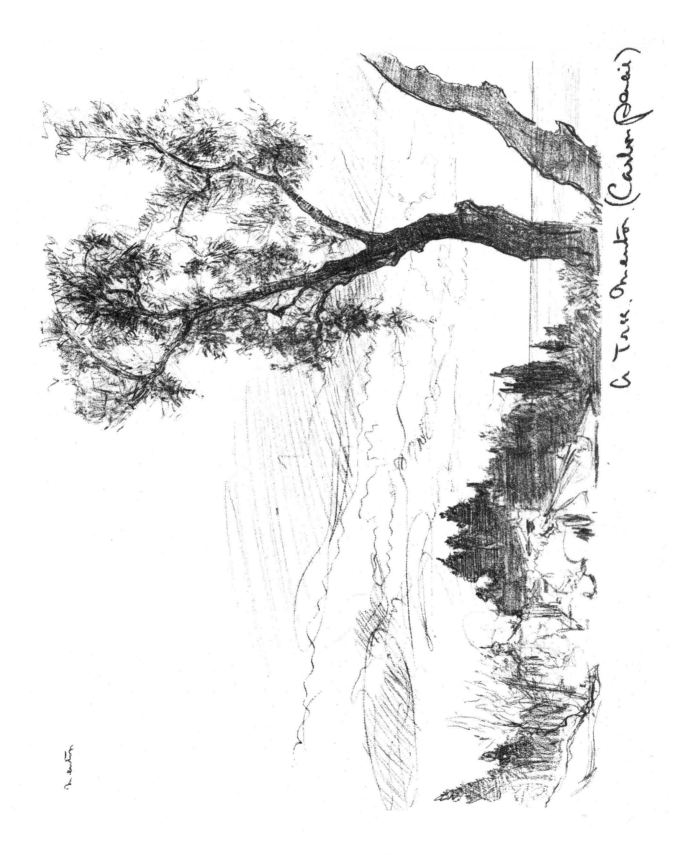

A Tree, Ometo (Carlos Parei)

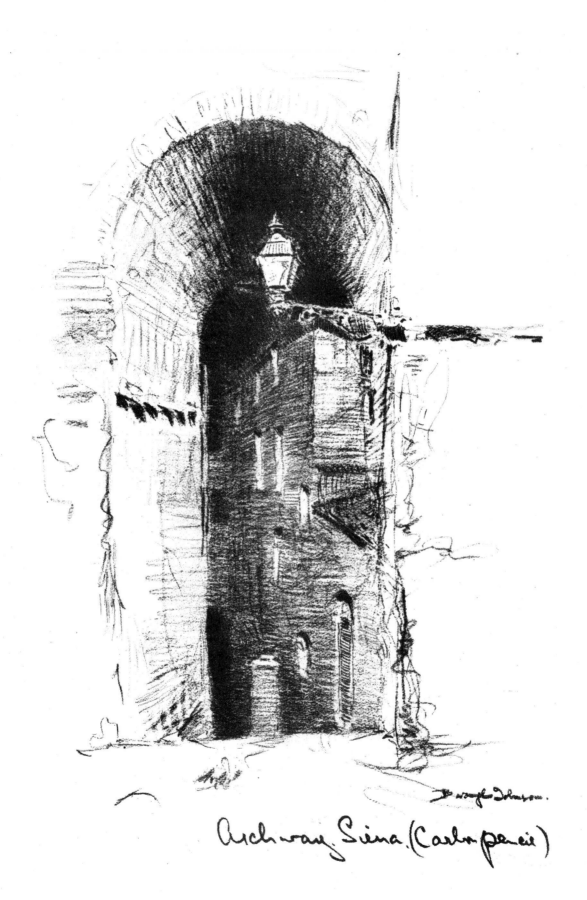

Archway Siena (Carbon pencil)

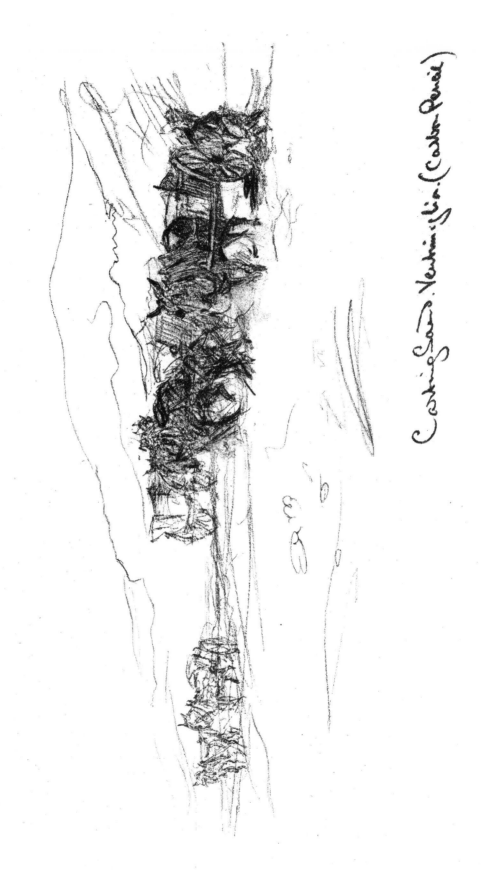

Cortinc̱gross Verbani̱gle. (Carbon Pencil)

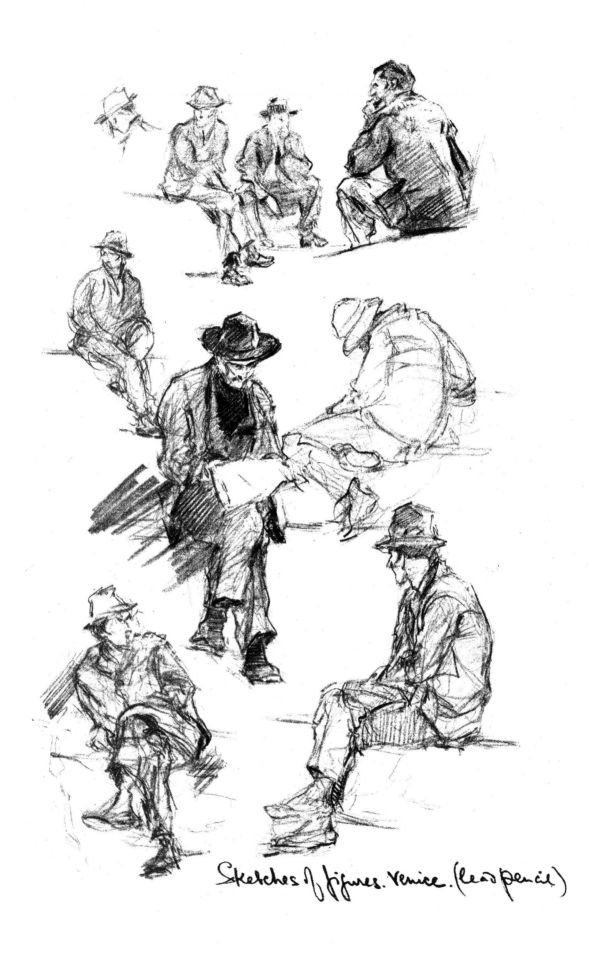

Sketches of figures. Venice. (lead pencil)

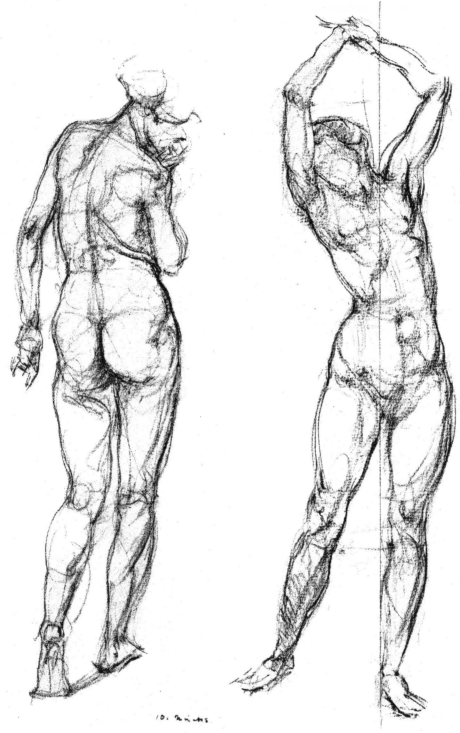

10. minutes

Burne Hogarth

Nude Studies (Chalk)

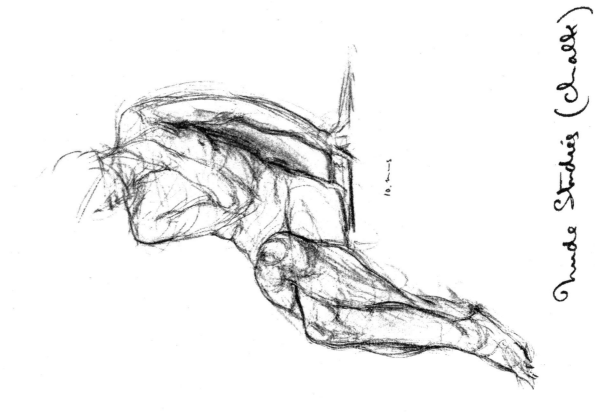

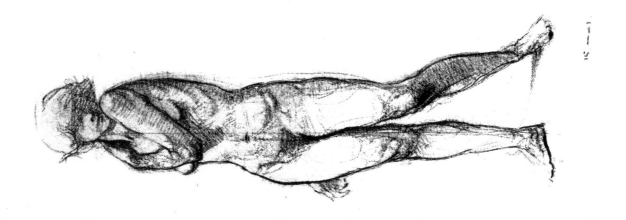

Nude Studies (Chalk)

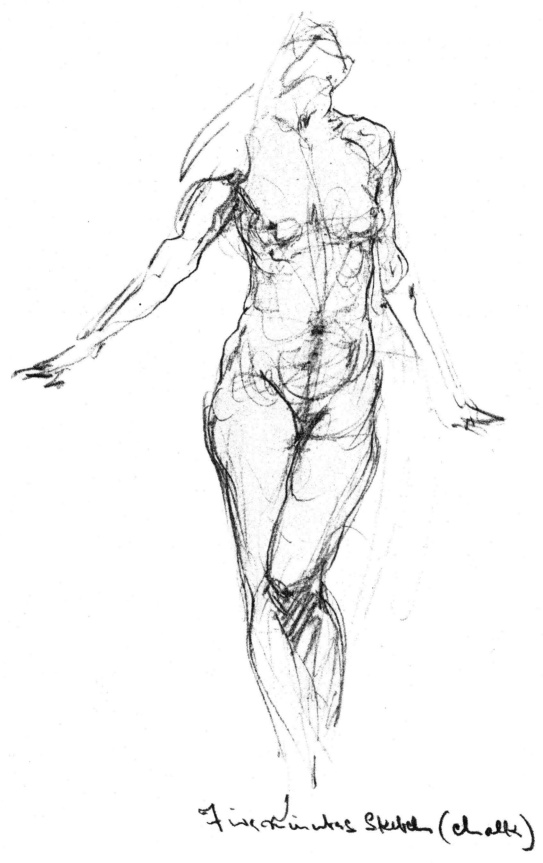

Five Minutes Sketch (chalk)

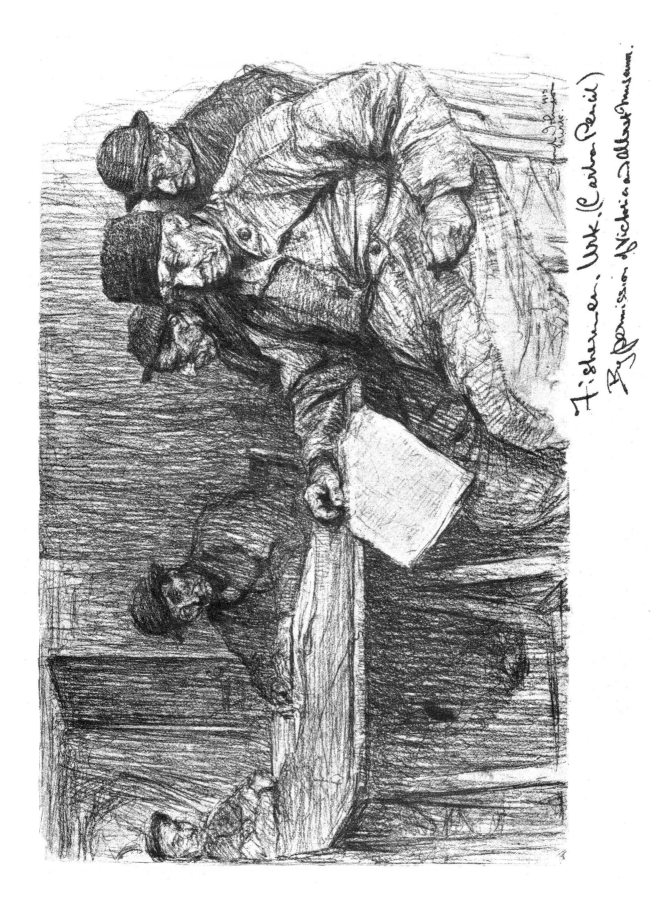

Fishermen. Ink. (Carbon Pencil)
By permission of Nicholas Alkemade Museum.

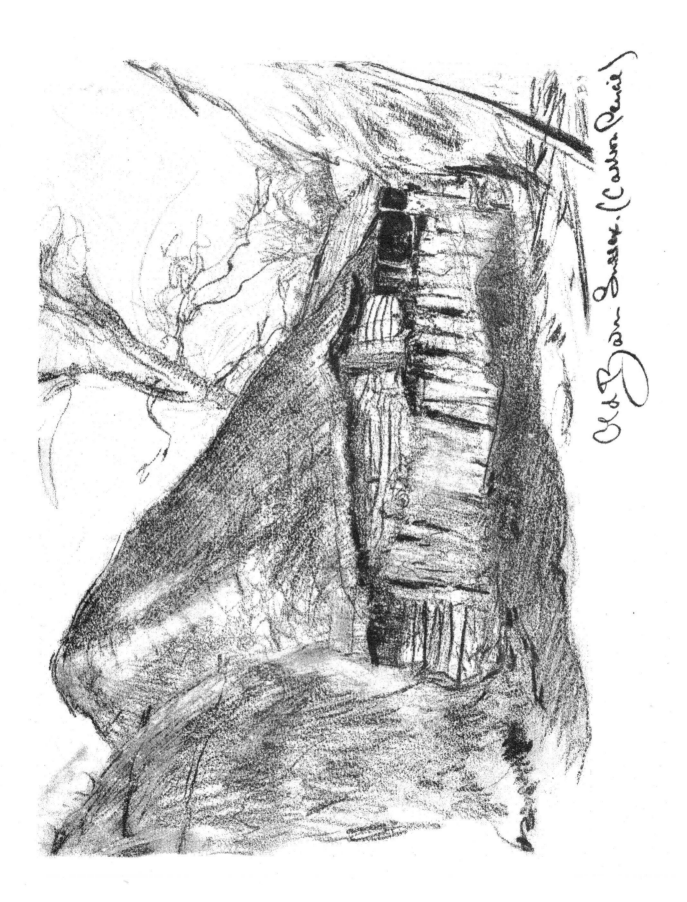

Old Barn Sussex. (Carbon Pencil)

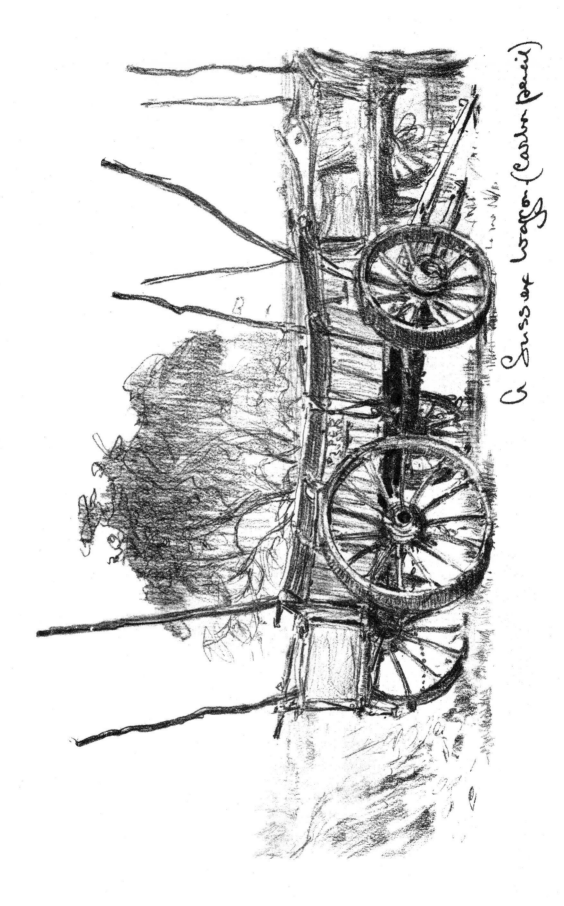

a Sussex waggon B.3

A Sussex waggon (Castr... pencil)